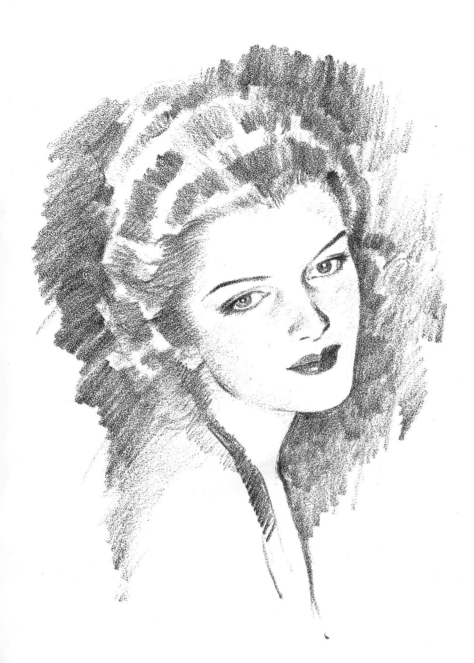

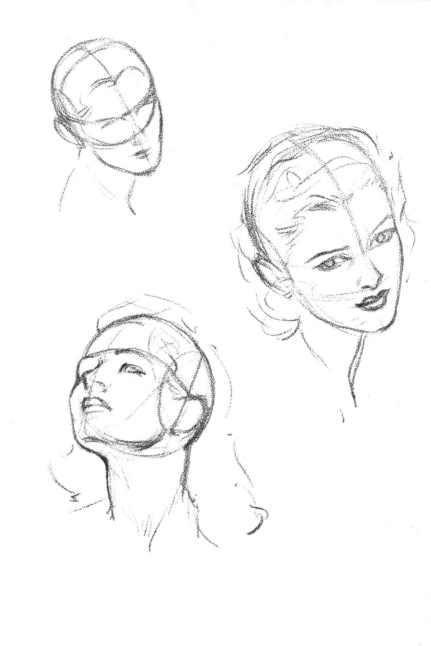

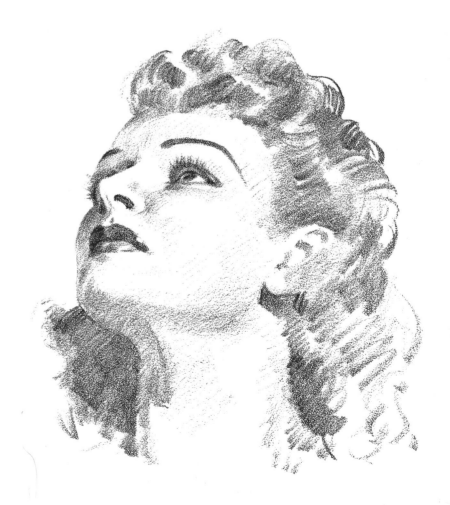

\mathcal{A}side from technical knowledge, I feel that the artist must have a certain reverence for the beauty of the construction of the head, the qualities of its forms that give it individuality, plus a desire for beauty of craftsmanship in the rendering. He should strive never to let technique become a routine formula, by which all heads are done in the same manner. Let him experiment constantly with the expression of his basic knowledge. Some heads can be done best by suggestion, others by complete detail and fidelity to life. Some will be more interesting if rendered in line, others by tonal suggestion. The result should never look as if it came off an assembly line. To vary your technical style is not easy; neither is keeping your thinking varied.

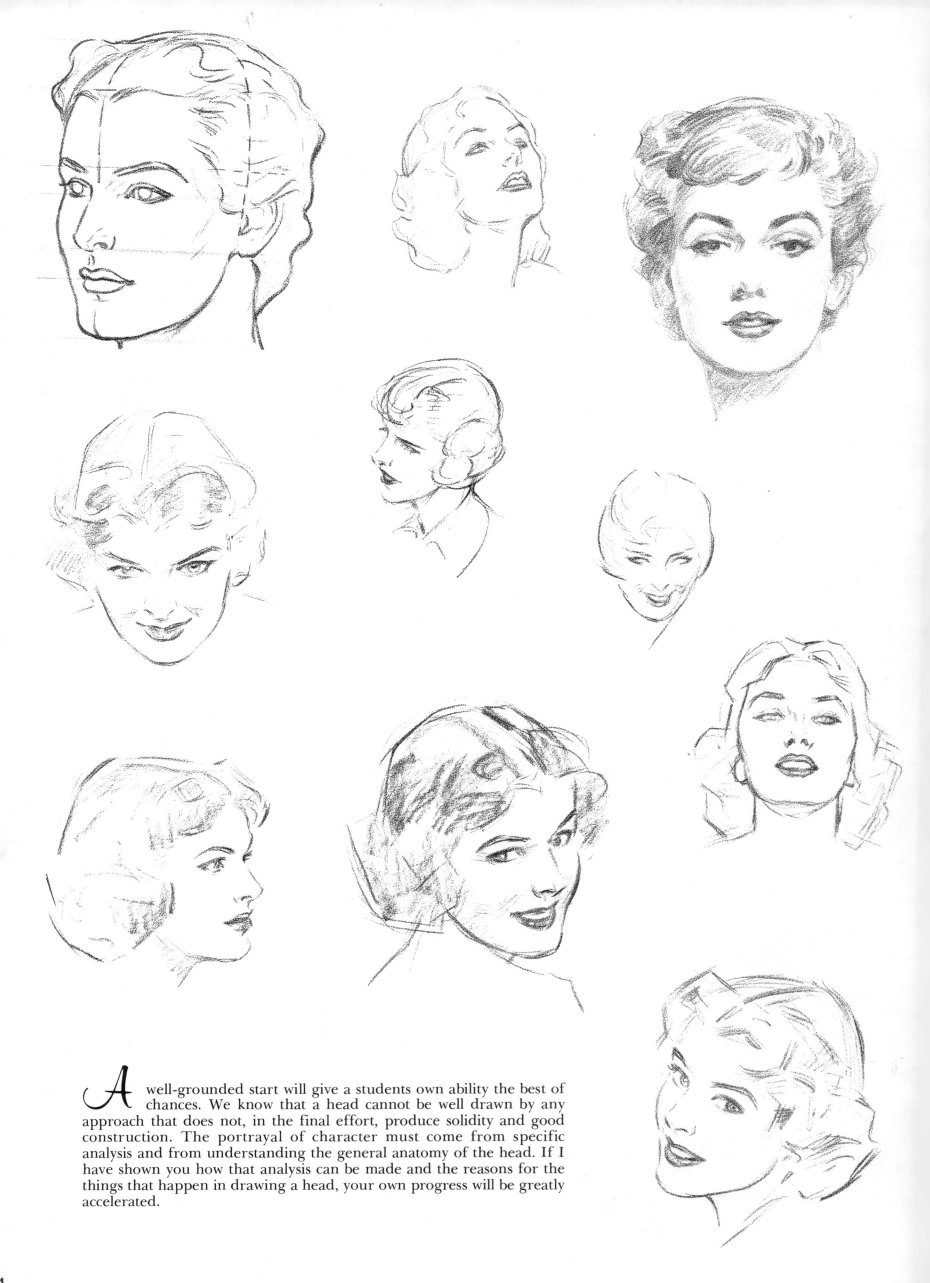

A well-grounded start will give a students own ability the best of chances. We know that a head cannot be well drawn by any approach that does not, in the final effort, produce solidity and good construction. The portrayal of character must come from specific analysis and from understanding the general anatomy of the head. If I have shown you how that analysis can be made and the reasons for the things that happen in drawing a head, your own progress will be greatly accelerated.

Apple Press
4.99.
743.49

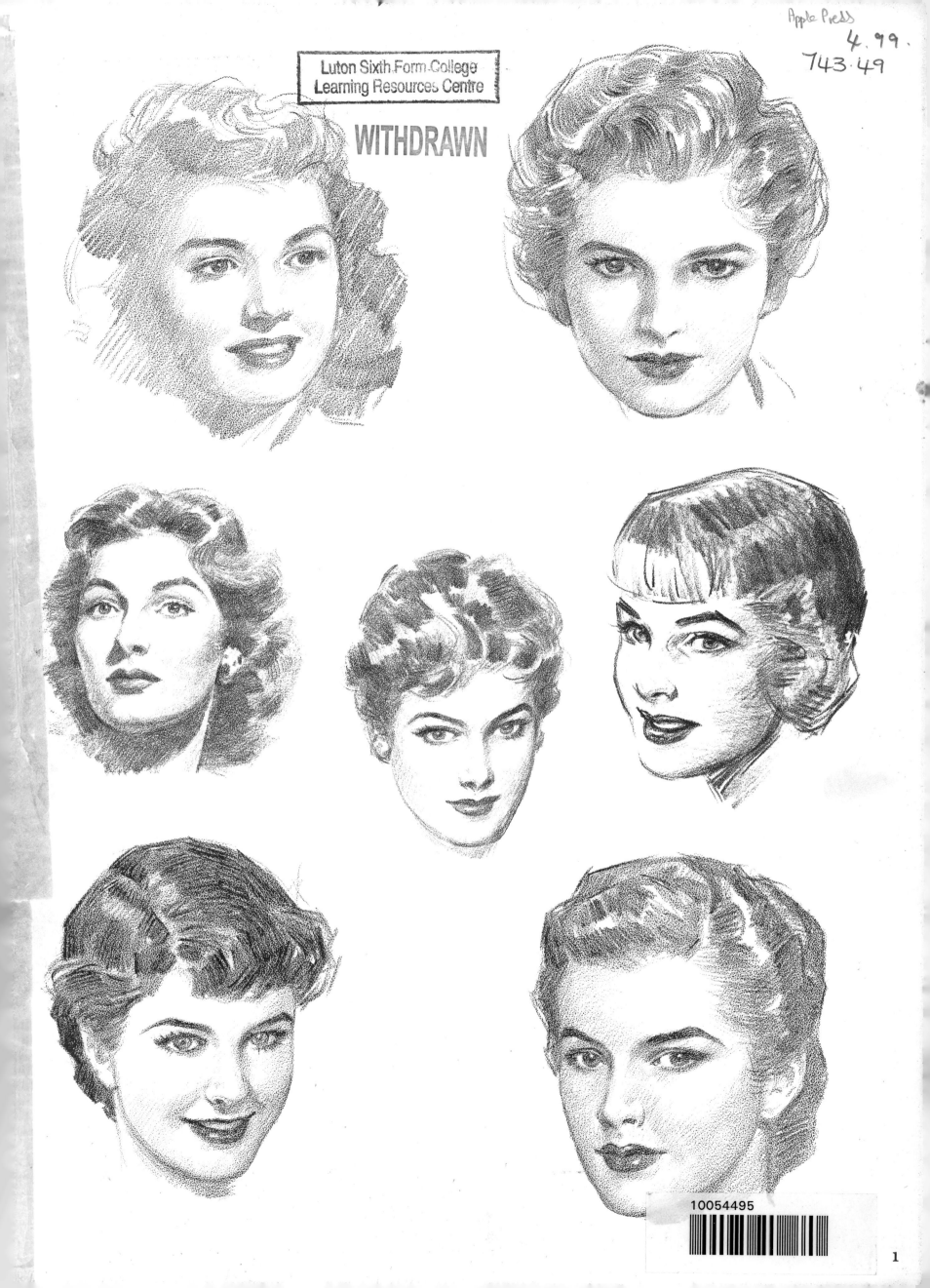

1

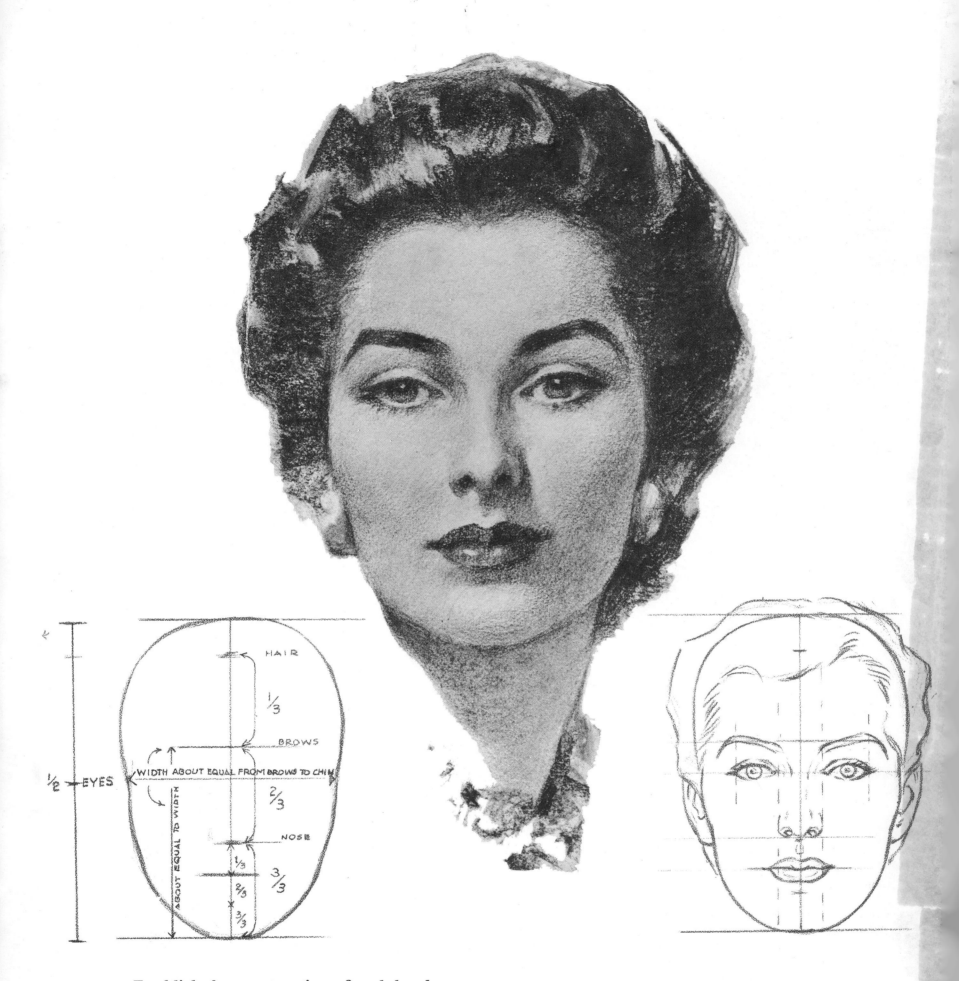

Establish the construction of each head

It is almost impossible to draw a beautiful woman unless the construction and placement of features are accurate. Keep the nostrils small and watch carefully the placement of the jaw and ears. The eyes and mouth must be in perfect placement and drawing to avoid some very strange and unpleasant results. Just now the brows are left fairly thick. A few years back they were just a thin line. Personally, I like natural-looking brows, but brows and lips, since they are so often made up, follow the trends of fashion. The same is true of hair-dos. Look for the mass effect of forms in the hair rather than the detail. Beauty of face is beauty of proportion, so learn the proportions first; then study your subject individually. The fashion magazines contain quantities of material for study, and will also keep you up to date on make-up and hair styles. Be careful not to draw flat lips. Place the highlight on the lip very accurately; if it is in the wrong place it can change the mouth and the whole expression.

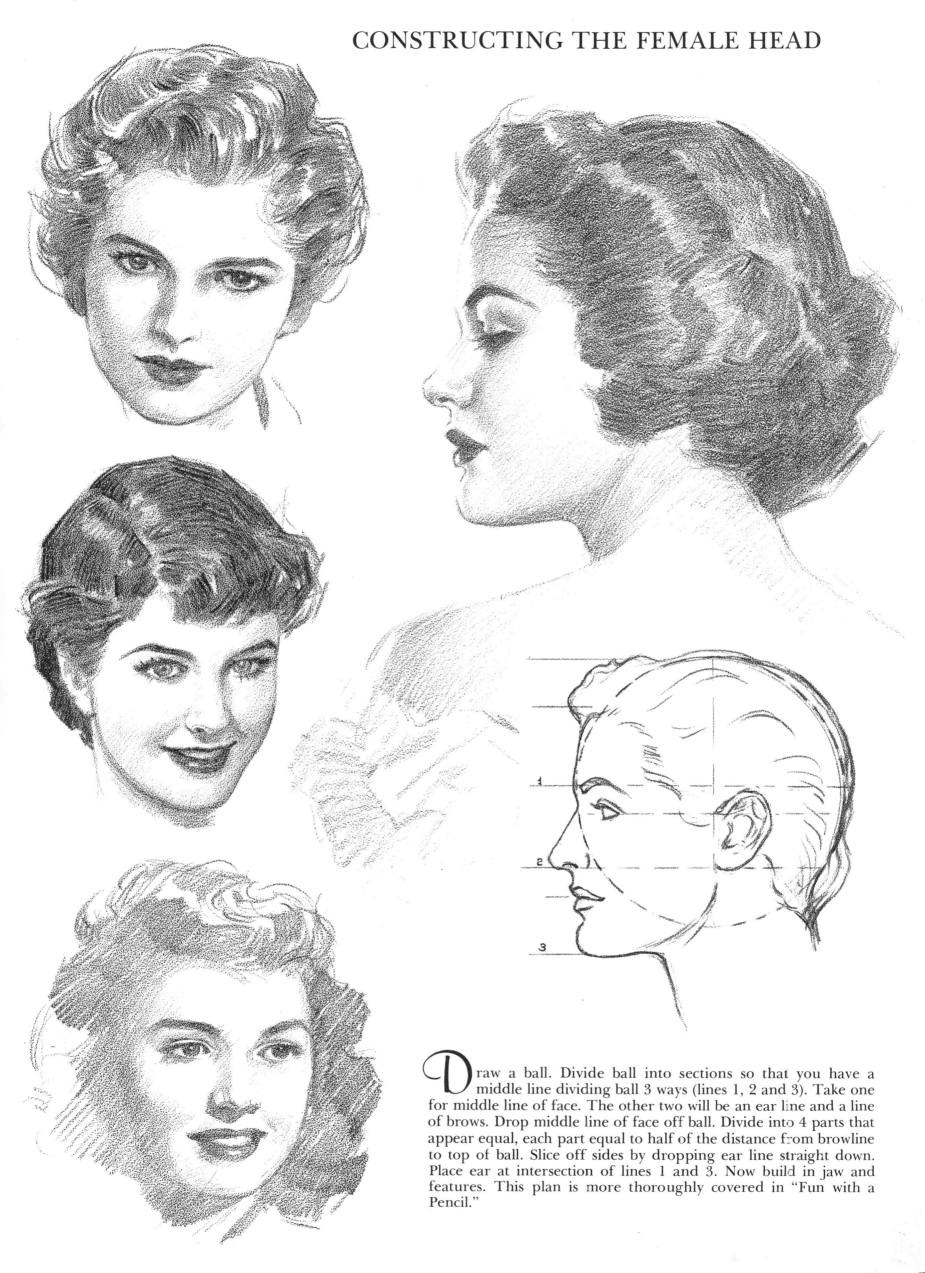

Draw a ball. Divide ball into sections so that you have a middle line dividing ball 3 ways (lines 1, 2 and 3). Take one for middle line of face. The other two will be an ear line and a line of brows. Drop middle line of face off ball. Divide into 4 parts that appear equal, each part equal to half of the distance from browline to top of ball. Slice off sides by dropping ear line straight down. Place ear at intersection of lines 1 and 3. Now build in jaw and features. This plan is more thoroughly covered in "Fun with a Pencil."

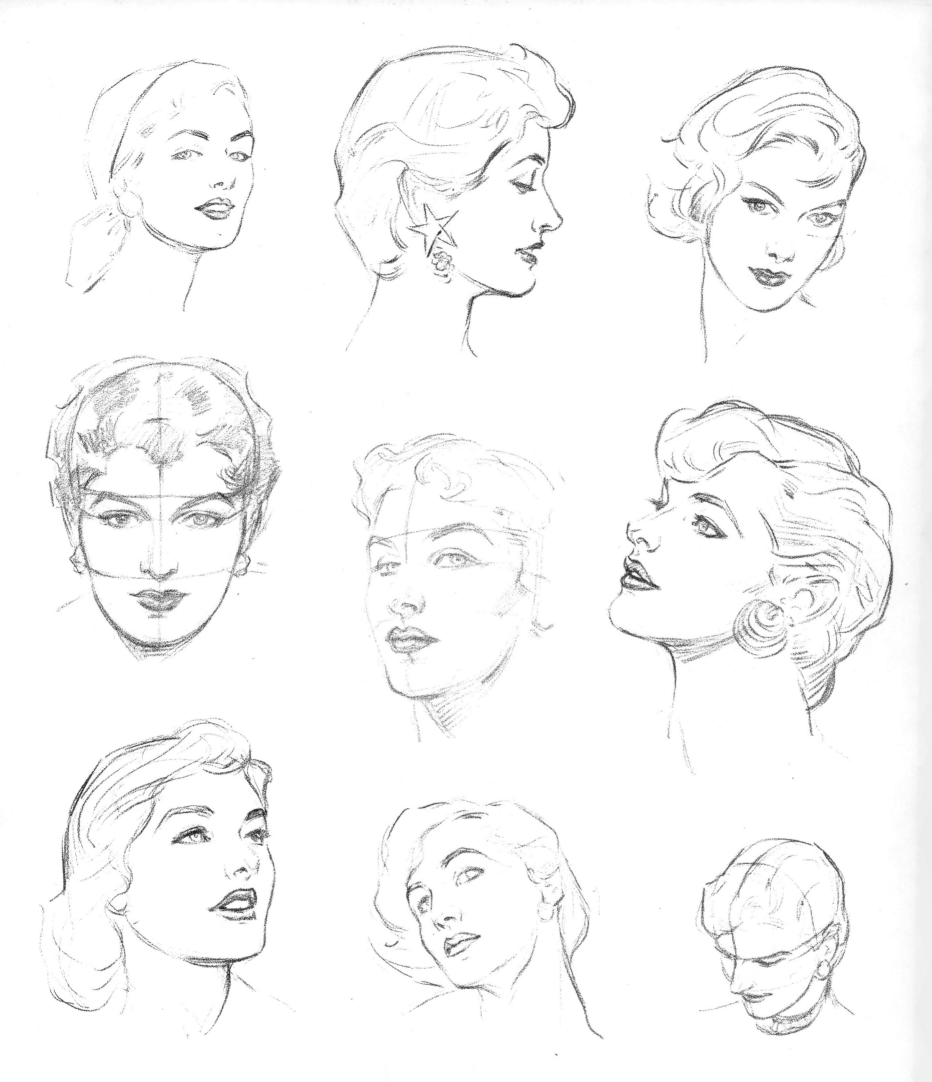

VARIETY IN SPACING CREATES TYPES

In order to create differences in type and character, we may decide not to follow the basic measurements of divisions too meticulously. By varying the proportions of the three divisions of the face, we come up with a good deal of variety in the results. There are thousands of possible combinations. It is fun to experiment with them.

Every head is an individual assemblage of shapes, lines, and spaces. Because of the variations of skulls and features, together with variations of spacing, millions of combinations occur. Forget every other face and concentrate on the one you are drawing. Accent the individual forms wherever you can. Start drawing real people, and collect clippings and photographs to practice from. Don't be tempted to trace; just draw.

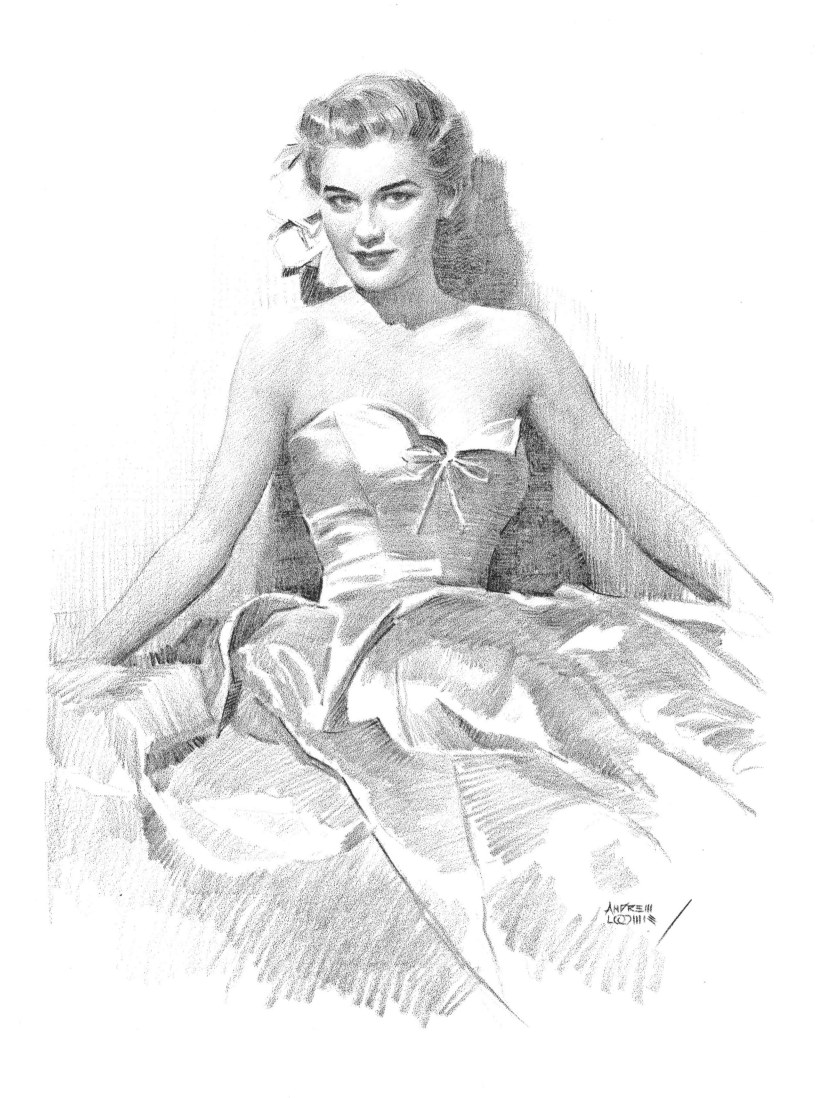

\mathcal{E}very artist should subscribe to the fashion magazines. They are the best possible sources for practice material. At the same time you are learning drawing and values, you are familiarizing yourself with the very important elements of style which mark the era of which your art must be a part.

TEEN-AGE BOYS

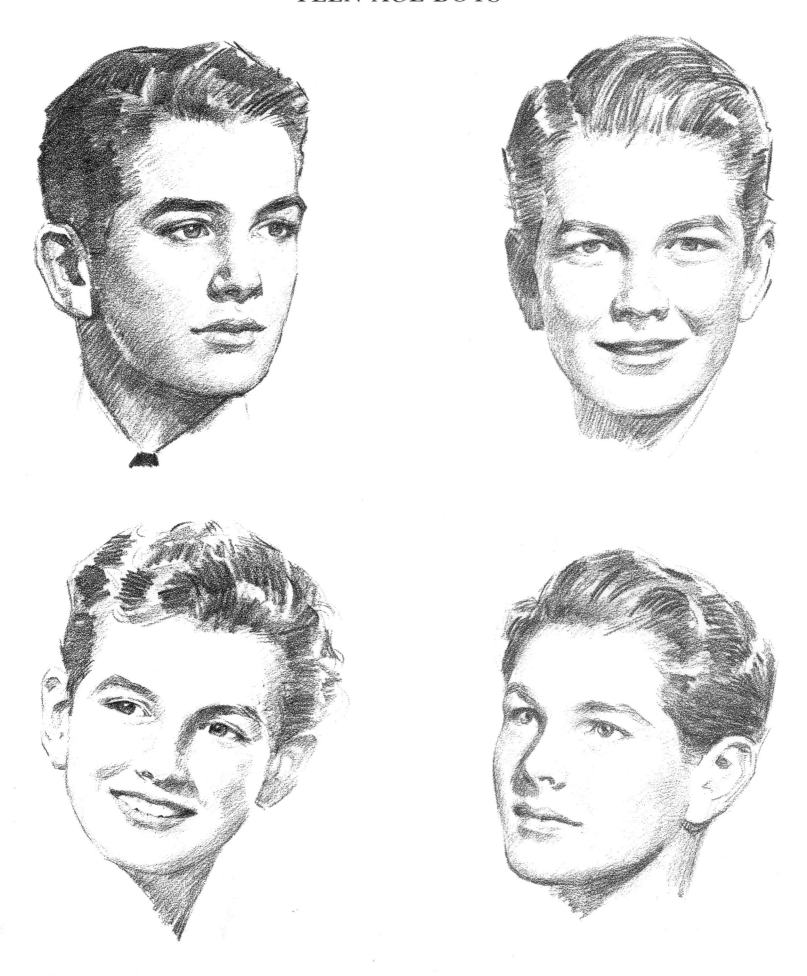

The proportions of the heads in teen-agers are almost identical with adults; the difference is largely a matter of feeling. In boys the bone structure has become quite evident, though it should not be stressed as much as in men's heads. There are no noticeable lines. The flesh is firm and still inclined to smoothness. The cheeks are smooth without much definition of the muscles. The jaw has developed considerably in a short time. The bridge of the nose has taken permanent shape. As the jaw and cranium have grown, the ears appear smaller in relation to the whole head than they do in a little boy. The cartilage of the ear is now well defined; the ears have lost much of their roundness and taken on more angular lines.

The hair has moved back somewhat from the temples. The brows have definitely thickened. The lips are fully developed in size. The chin has come forward in permanent shape.

The only bone not fully developed is the corner of the jaw. This continues to develop, research shows, until the age of twenty or more. I suspect the cranium itself does not reach its maximum growth until full maturity, though further growth does not perceptibly affect the proportions of the head.

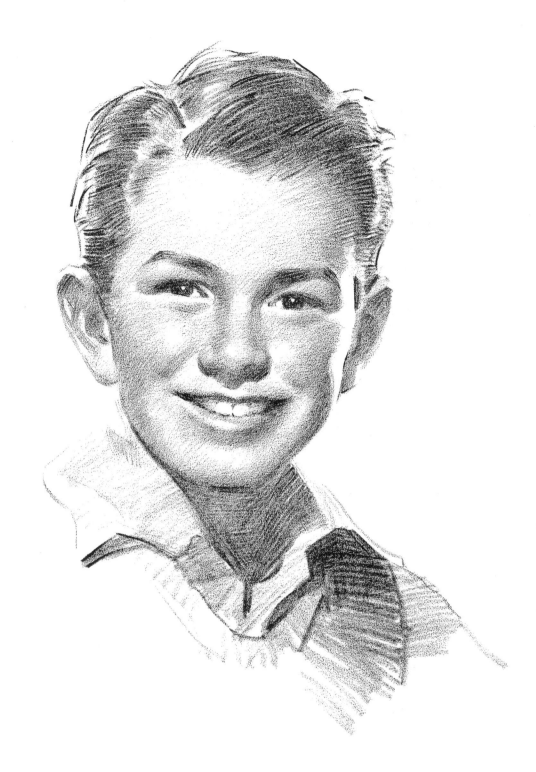

Teen-agers are popular subjects in fiction, advertising, and portraits. Since the proportions of the head are so nearly those of the adult head, we are almost back to where we started, but I hope with much more understanding.

In drawing teen-age boys and girls we must take into consideration the great variety of types. In boys, bony faces with well-marked muscles are associated with athletic types. The muscular activities contribute to a certain leanness. Some boys grow so fast they are robbed of some vitality; others simply do not lean toward athletics. Another type of teen-age boy has a round face, long legs and arms and large hands and feet, tends to drape himself over anything suitable to rest upon, and hates effort—especially home chores. As a rule, these boys develop more energy later when they attain full growth.

No one detail of the bone structure is of great importance, but its total shape is of paramount importance. Within the shape we must locate the eye-sockets, spacing them carefully on either side of the middle line. We locate the two cheekbones opposite each other, and the bridge of the nose, which must lie on the middle line at the top and extend out from the middle line at the bottom. We locate the corner of the jaw and bring the jaw line down to the chin. Every head must be constructed so that all the features balance on the middle line. This gives you more of the actual appearance of the finished portrait.

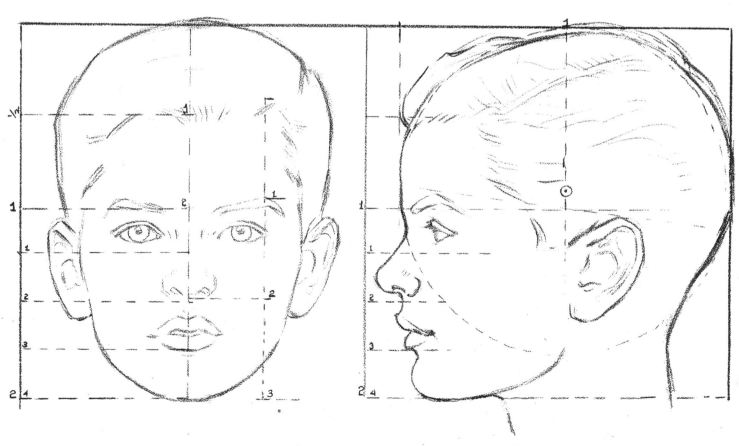

PROPORTIONS OF THE LITTLE BOY'S HEAD

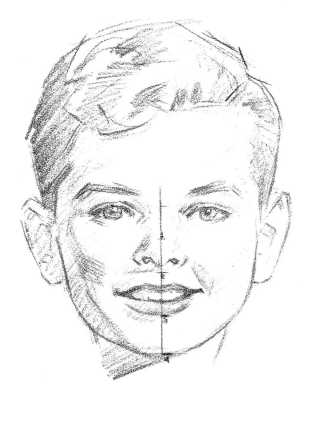

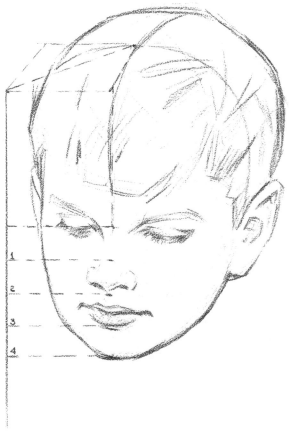

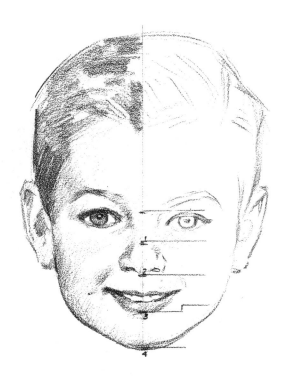

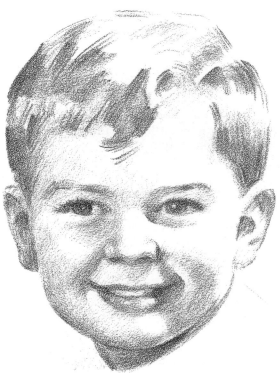

*I*n the small boy the up-and-down proportions are about the same as those in the older baby. But now the face is relatively narrower, coming well inside the square in the front view. The eyes appear smaller, because they do not grow and the face does. We can only use the large "button" eyes for very young children. The jaw and chin of the boy pictured above have started to grow, making the chin more prominent. The bridge of the nose is higher, and the nose is a little longer, almost touching the bottom of the second quarter. The lips touch the bottom line of the third quarter. At a fairly early age a full shock of hair grows. This accentuates the large cranium but keeps the face looking small and adds to the cuteness of the child. If a child has curly hair, mothers sometimes let the hair grow until it begins to look grotesque. So it is well to know where the cranium really is.

It is hard for little boys to sit still; in drawing them, as in drawing babies, practice from photographs and clippings. Note that the ear is coming up to the halfway line. Little boys' heads seem to extend far back because the neck is small and the muscles which attach to the base of the skull are not yet developed. Notice particularly that the nostrils have grown and the upper lip appears to be somewhat shorter. The ear grows considerably during this period and the one which follows. I believe the ear is fully developed by the time the child is ten or twelve. The space from the nose to the ear still appears quite wide. Lashes are quite long. The hair grows quite well over the temples.

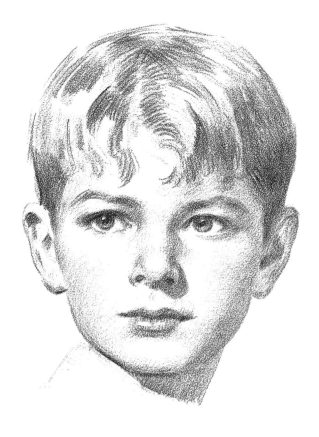
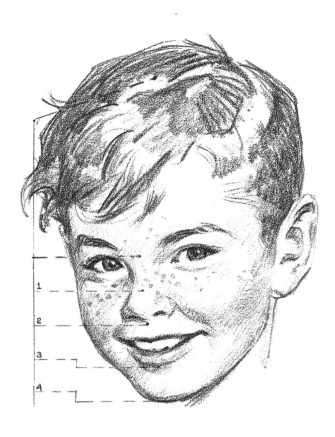
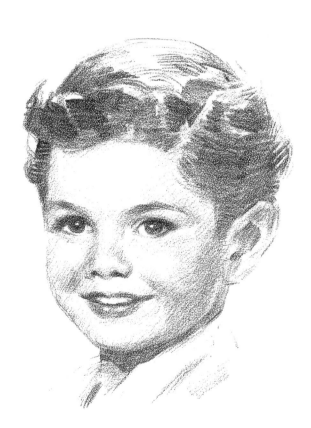
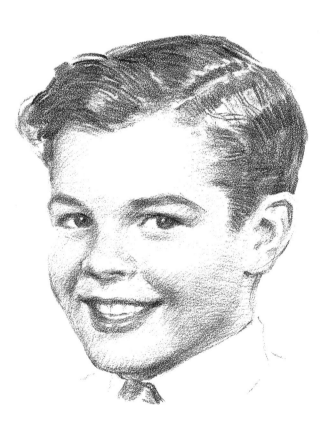

As one progresses in the drawing of children, he becomes impressed with the distinctive character and personalities he finds. Children register as many feelings and emotions as adults, and more freely and obviously. As we grow older we learn to hide our real emotions, sometimes too deeply. Most children are much more truly themselves than adults are.

If you plan to do advertising illustration, or are already in that field, you will find drawing growing boys and girls very remunerative. Practically all foods are advertised to mothers with growing children and the children appear in profusion in such advertising. You can practice from the heads here, or find others in the women's magazines that offer excellent practice.

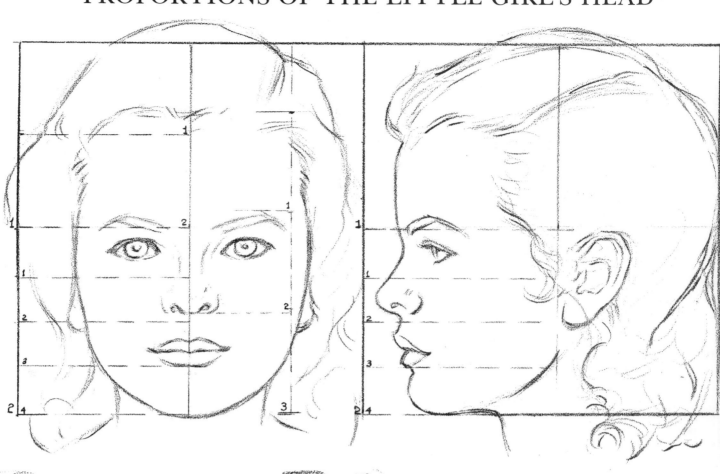

D raw heads in outline until you are satisfied that the age and expression look right. There is no point in adding tone to a head that does not appeal to you. The tone can only build up the forms already established. If they are wrong, tone does little to help. Sometimes a head in outline may look better than one completely finished.

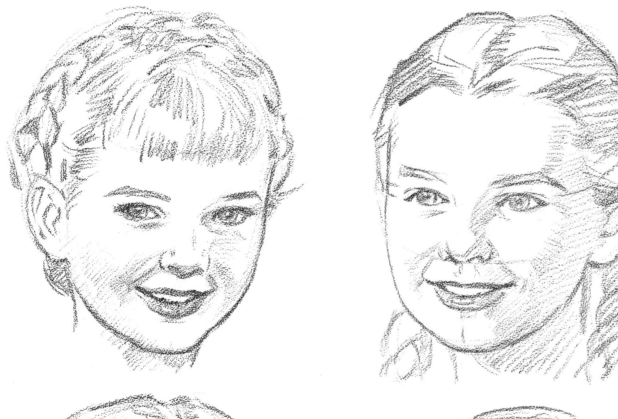

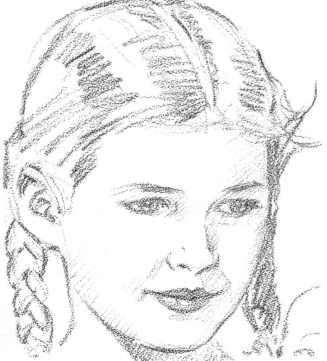

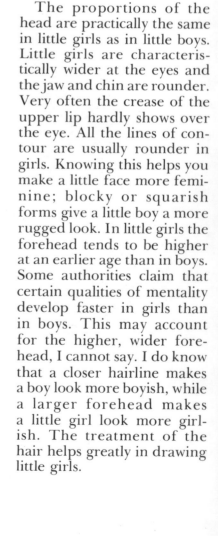

The proportions of the head are practically the same in little girls as in little boys. Little girls are characteristically wider at the eyes and the jaw and chin are rounder. Very often the crease of the upper lip hardly shows over the eye. All the lines of contour are usually rounder in girls. Knowing this helps you make a little face more feminine; blocky or squarish forms give a little boy a more rugged look. In little girls the forehead tends to be higher at an earlier age than in boys. Some authorities claim that certain qualities of mentality develop faster in girls than in boys. This may account for the higher, wider forehead, I cannot say. I do know that a closer hairline makes a boy look more boyish, while a larger forehead makes a little girl look more girlish. The treatment of the hair helps greatly in drawing little girls.

RHYTHMIC LINES IN THE HEAD

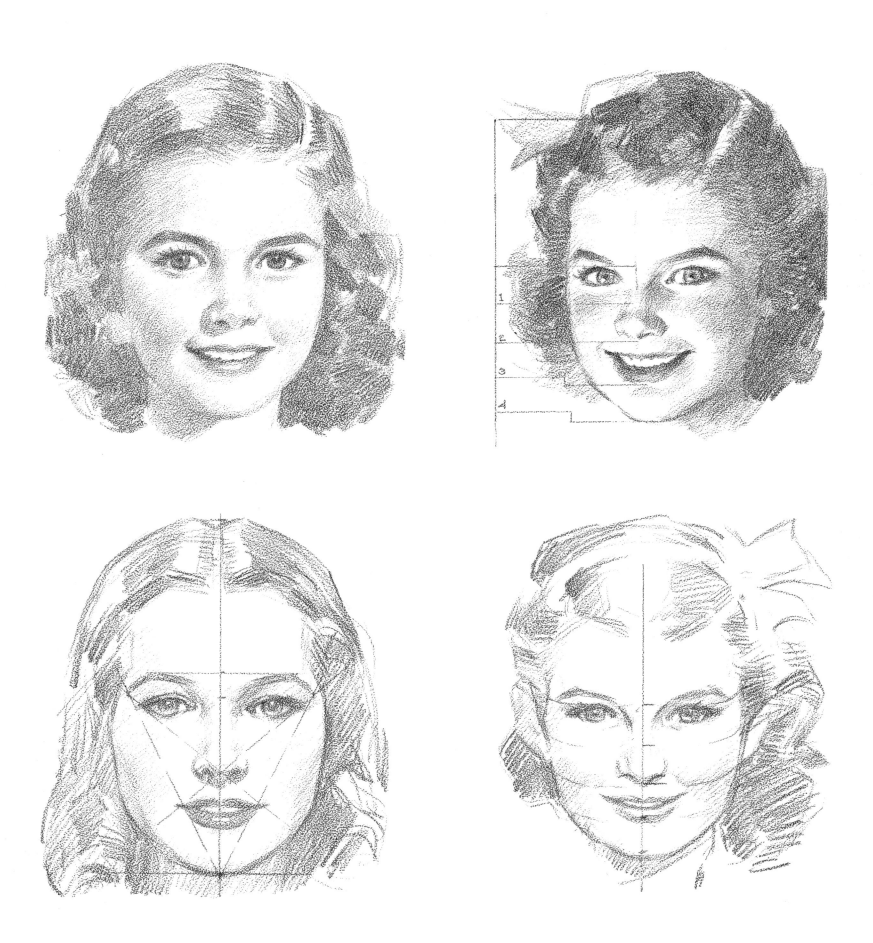

\mathcal{I}t is interesting to search for the rhythmic lines in faces. You will find rounded or curved lines in opposition to angular and blocky lines. The blocky treatment helps to get away from the tight photographic approach. Then the head looks drawn not traced. There is charm in curves but square forms have weight and solidity. You can produce happy results by combining the two instead of merely copying every waver of every edge in exact outline. In this way you set a feeling of design, and at the same time render solid form.

At the right, above, we have the usual quarter spacing. It is interesting and helpful to note how the diagonals cross in a young girl's head. The diagonals from the corners of the eyes through a point at the middle of the base of the nose also cut through the corners of the mouth; those from the outer ends of the brows cut through the corners of the mouth to a point at the base of the middle of the chin.

13

YOUNG AND OLD

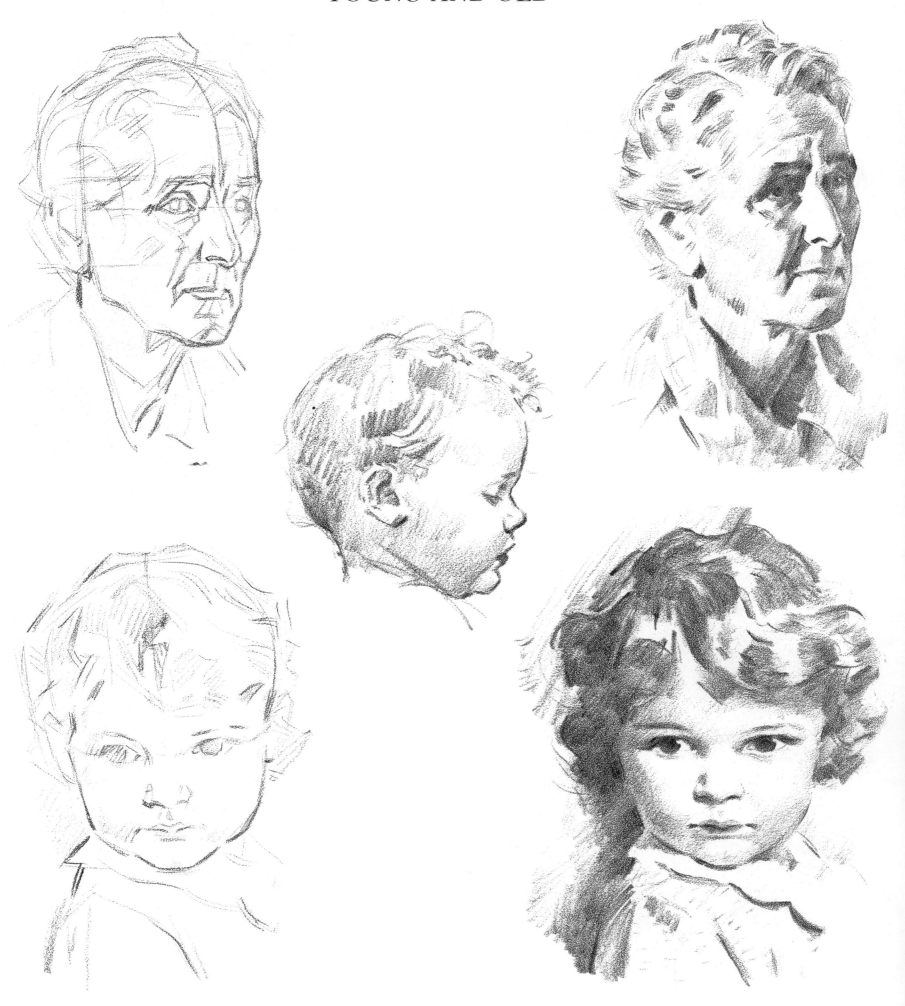

For character drawing make a number of studies of people, a baby, a child or an old person. The pose, the expression, the age all count. The upper lip may be long or short, the cheeks full or sagging. By different combinations of these, you can produce an almost endless variety of characters. It will be great fun for you to experiment.

Although the construction of any head involves more or less the same problems, this book is divided into sections on drawing men, women, and children of various ages. As we shall see, though the technical differences are slight, there is considerable difference in approach and feeling. Now let's get to work in earnest.

PRACTICE HEADS ALL YOU CAN

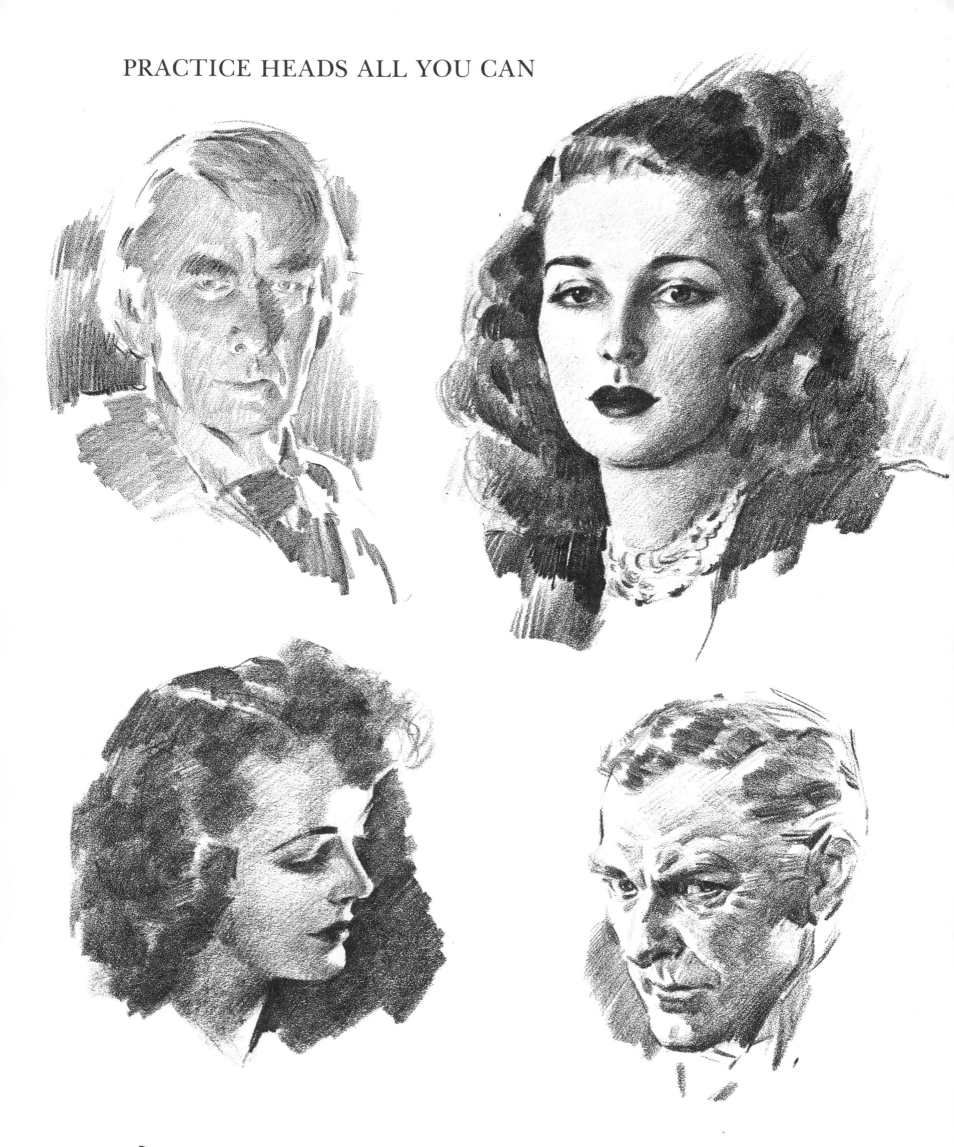

Start a sketch book now of practice heads. Draw all types and characters, they are all about you, willing to pose. Draw some from life, others from clipping; nothing can help you more. Draw one a day and fill your book.

There is no better way to study than to practice all types and characters. Heads have all the major problems of real drawing.

PLANES

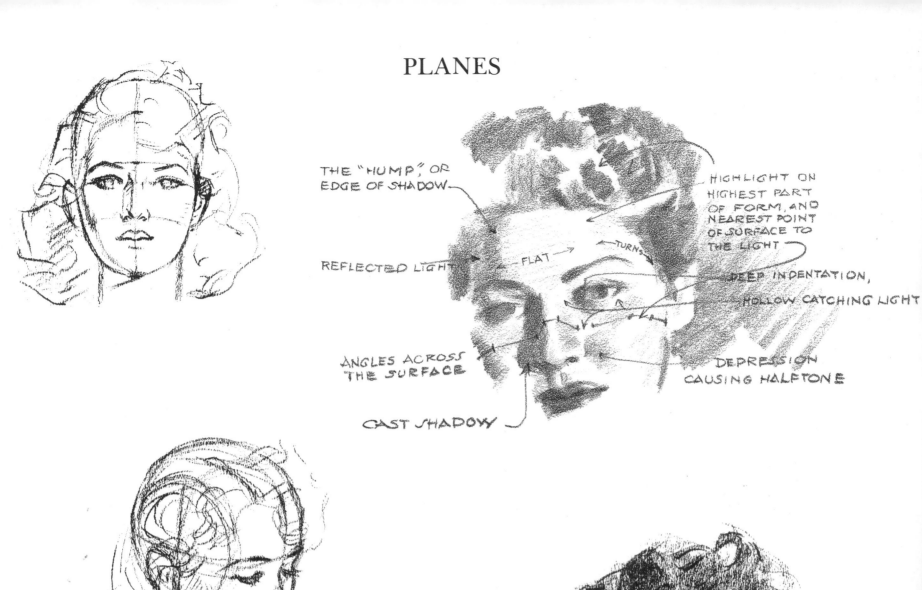

THE "HUMP" OR EDGE OF SHADOW

HIGHLIGHT ON HIGHEST PART OF FORM, AND NEAREST POINT OF SURFACE TO THE LIGHT

REFLECTED LIGHT · FLAT → TURNS

DEEP INDENTATION, HOLLOW CATCHING LIGHT

ANGLES ACROSS THE SURFACE

DEPRESSION CAUSING HALFTONE

CAST SHADOW

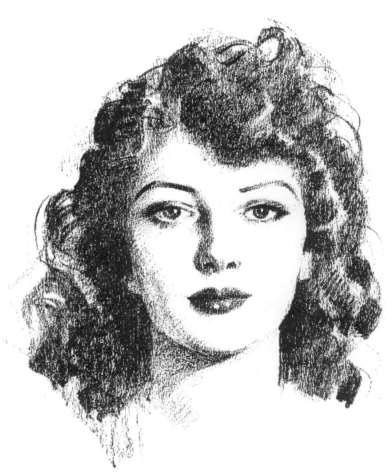

The over-all proportions of the female head vary only slightly from those of the male head, but the bone and muscle structure is lighter and less prominent. In commercial art feminine types with rather firm jaws seem to have more appeal than do the very rounded. Women's eyebrows are usually a little higher above the eyes than men's are. The mouth is smaller; the lips are more full and rounded, and the eyes slightly larger. Do not stress the jaw and cheek muscles.

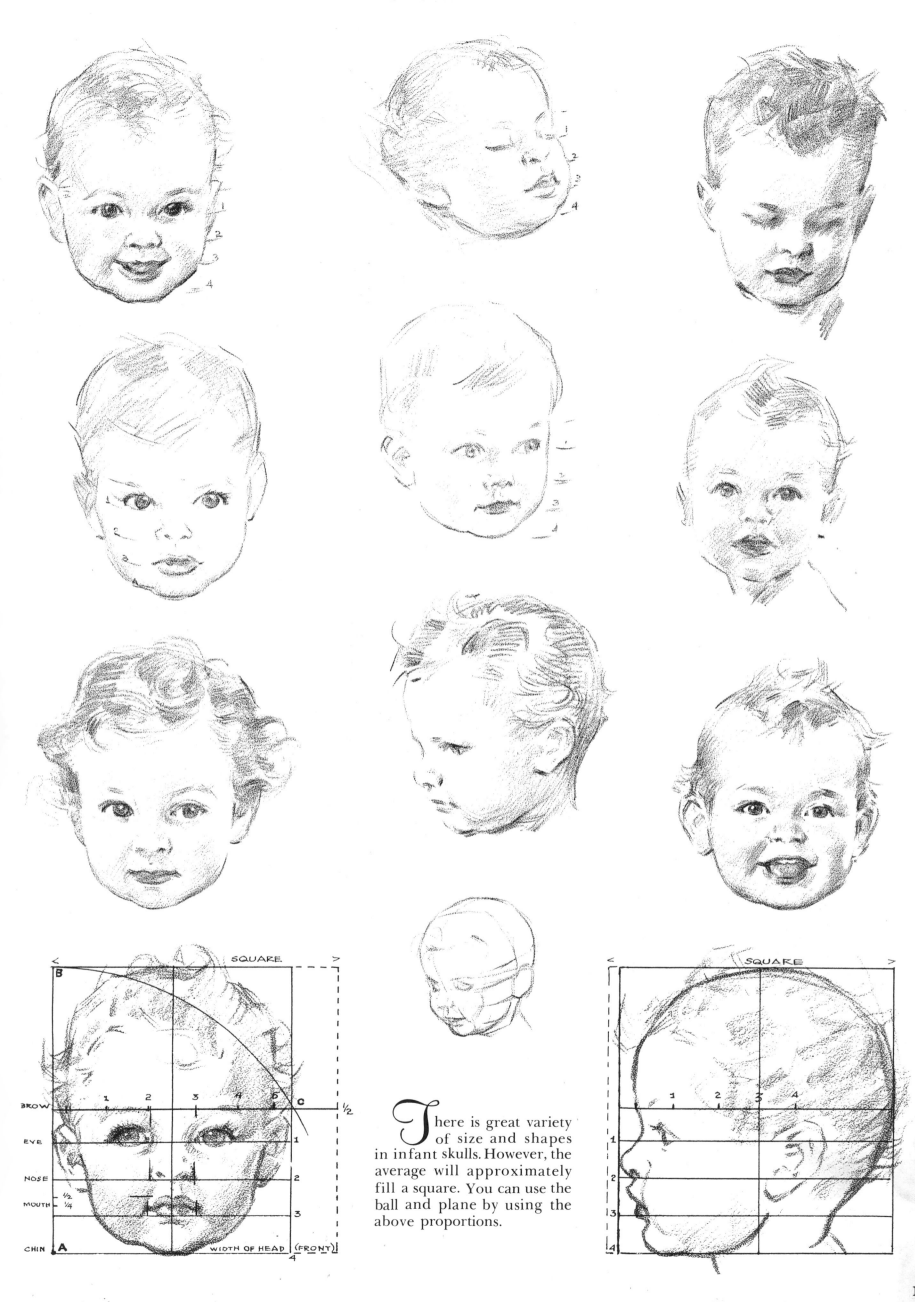

There is great variety of size and shapes in infant skulls. However, the average will approximately fill a square. You can use the ball and plane by using the above proportions.

BROW
EYE
NOSE
MOUTH
CHIN

SQUARE
WIDTH OF HEAD (FRONT)

SQUARE

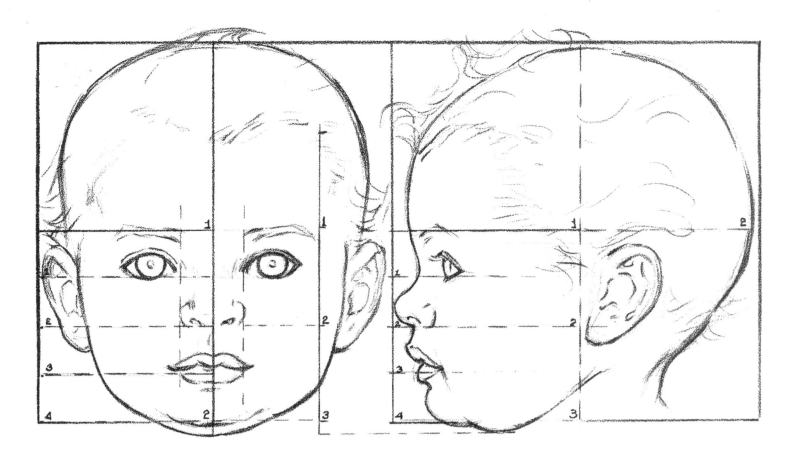

MORE STUDIES OF BABIES

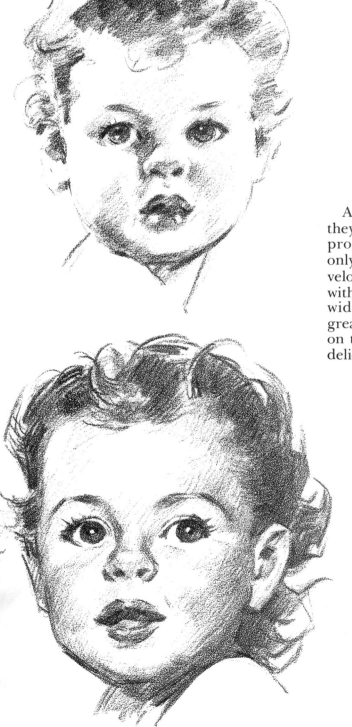

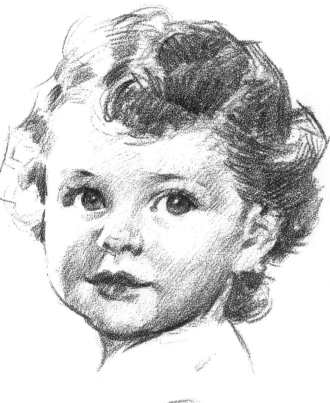

As babies grow more hair, they look older, although the proportions have changed only slightly. Some babies develop long eyelashes, which, with their already large and widely spaced eyes, give a great deal of appeal. Go easy on the eyebrows; keep them delicate.

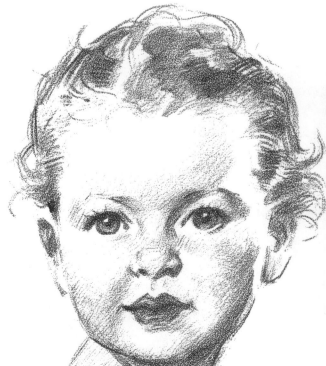

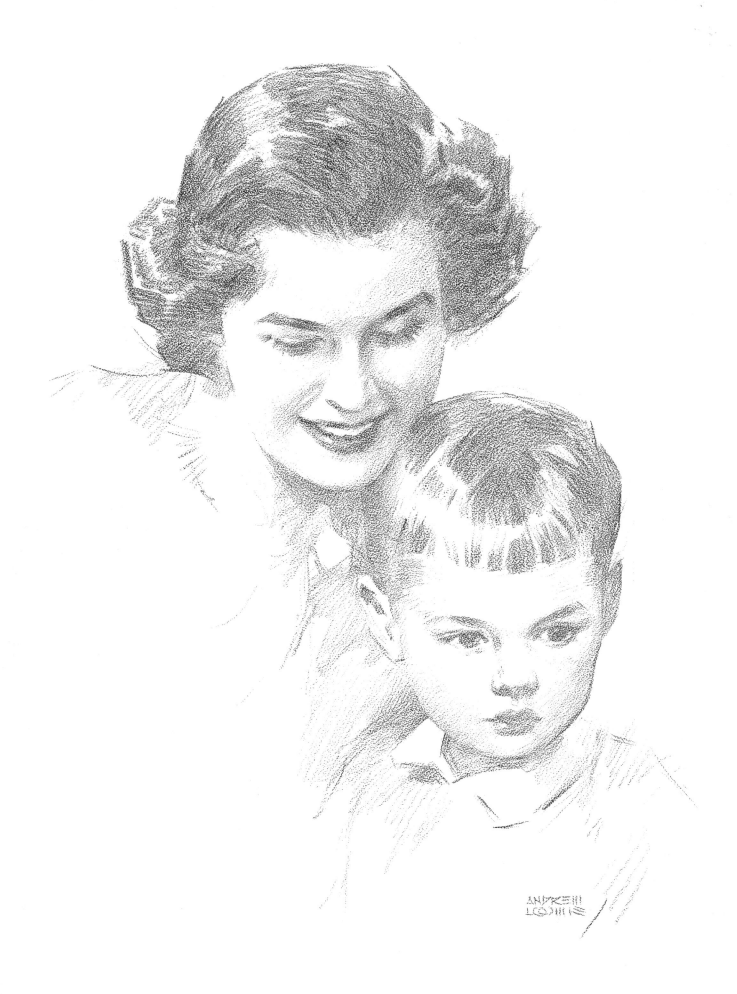

As the baby head develops, the face gets longer in proportion to the cranium, which has the effect of moving the eyes and brows upward in the head. Actually, the development of the lower jaw brings that downward, and the nose and upper jaw also lengthen. As a result of these changes the eyes of an adult, and even of a teen-ager, are on the middle line of the head. It is most important to know this because the setting of the eyes in relation to the middle line across the face is the direct way to establish the age of a child. The iris is fully developed in the baby, and will never get any larger; consequently the eyes look much smaller in the adult face. However, the opening between the eyelids does widen, so that we see more of eyeball in an adult than we do in a baby.

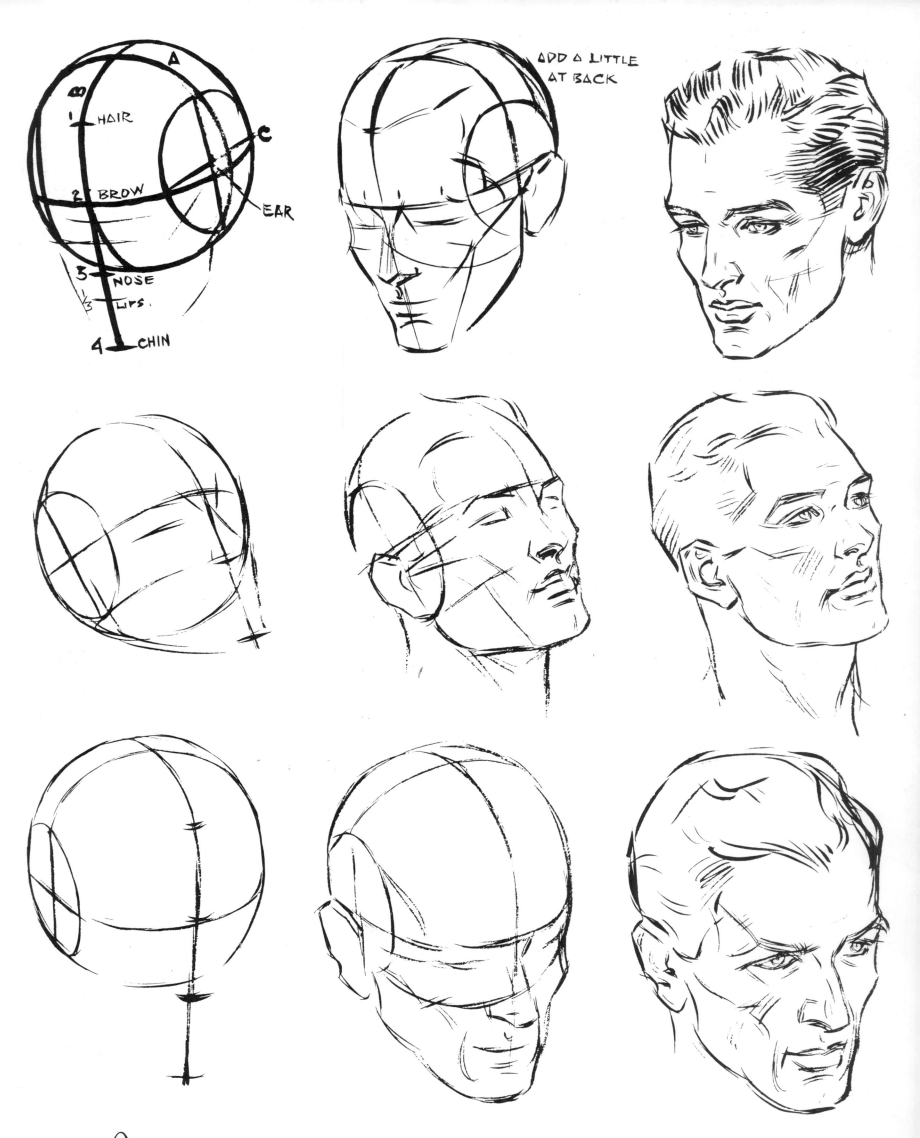

In my first book, Fun with a Pencil, I set about to work out a plan for head construction that I consider almost foolproof. I repeat the general plan as a possible aid here.

Consider the head a ball, flattened at the sides, to which the facial plane is attached. The plane is divided into three equal parts (lines A, B, and C). The ball itself is divided in half. Line A becomes the earline, B the middle line of the face, and C the line of the brows. The spacing of the features can then be laid out on these lines. The plan holds good for either male or female, the difference being in the more bony structure, the heavier brows, the larger mouth in the male. The jaw line in the male is usually drawn more squarely and ruggedly.

BLOCKS AND PLANES

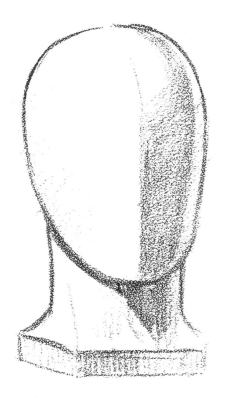 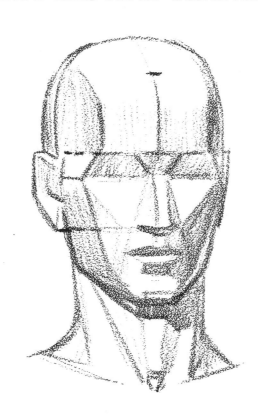 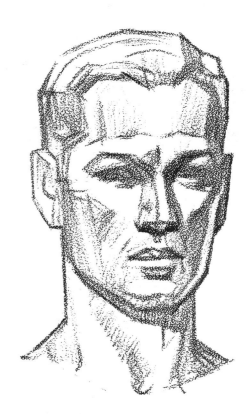

The simple form developed to the complex, through the use of planes. These average planes should be learned. They are the basis for lighting.

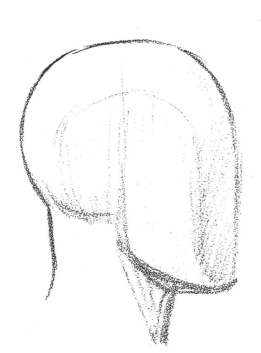 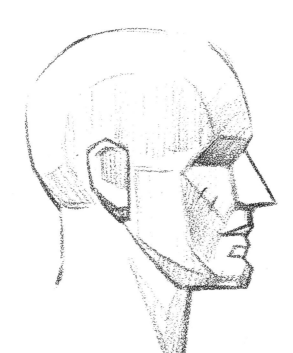 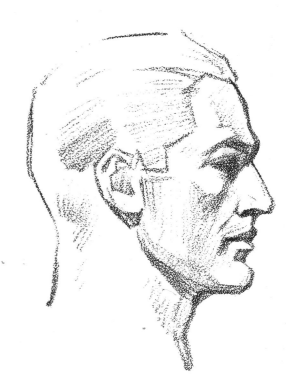

The planes side view. Get some clay and model the planes so you can light them different ways. Then draw them.

 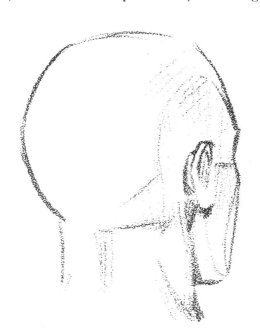 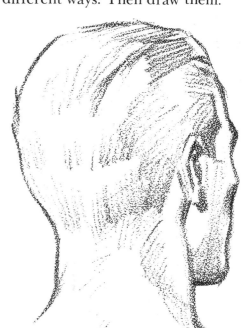

Back views are most difficult unless form and planes are understood.

COMBINING ANATOMY, CONSTRUCTION, AND PLANES

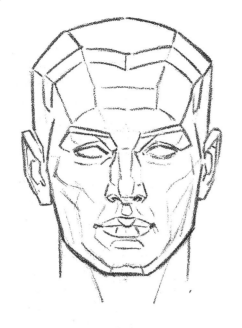

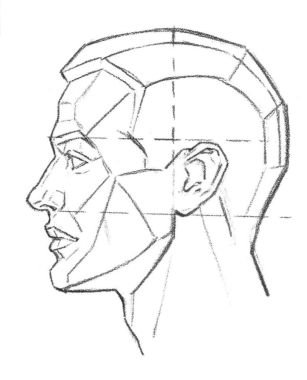

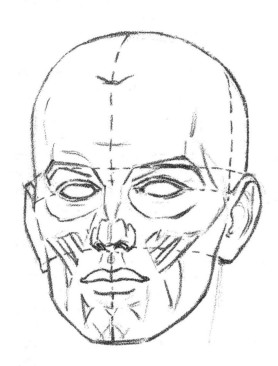

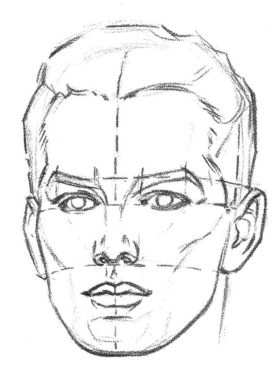

This page is one of the most important in the book, since it shows the stages of drawing a head from the anatomy and construction, through the outline, to the planes and the final completion of the drawing. It would be impossible to follow without considerable study of the preceding information, not in order to copy this head, but to draw one yourself. Study this page carefully; you will find it invaluable for reference.

The planes of the head should be memorized, for through them we have a foundation for rendering the head in light and shadow. Begin with the basic planes (top, left), and study them until they are fixed in your mind. Then take up the secondary planes. From these sets of planes almost any head can be built. The surface varies with the individual character, but with the planes shown here you can produce a well-proportioned, manly head.

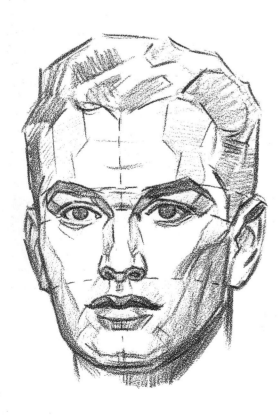

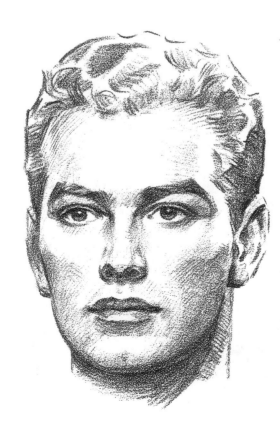

SIMPLIFIED BONE STRUCTURE

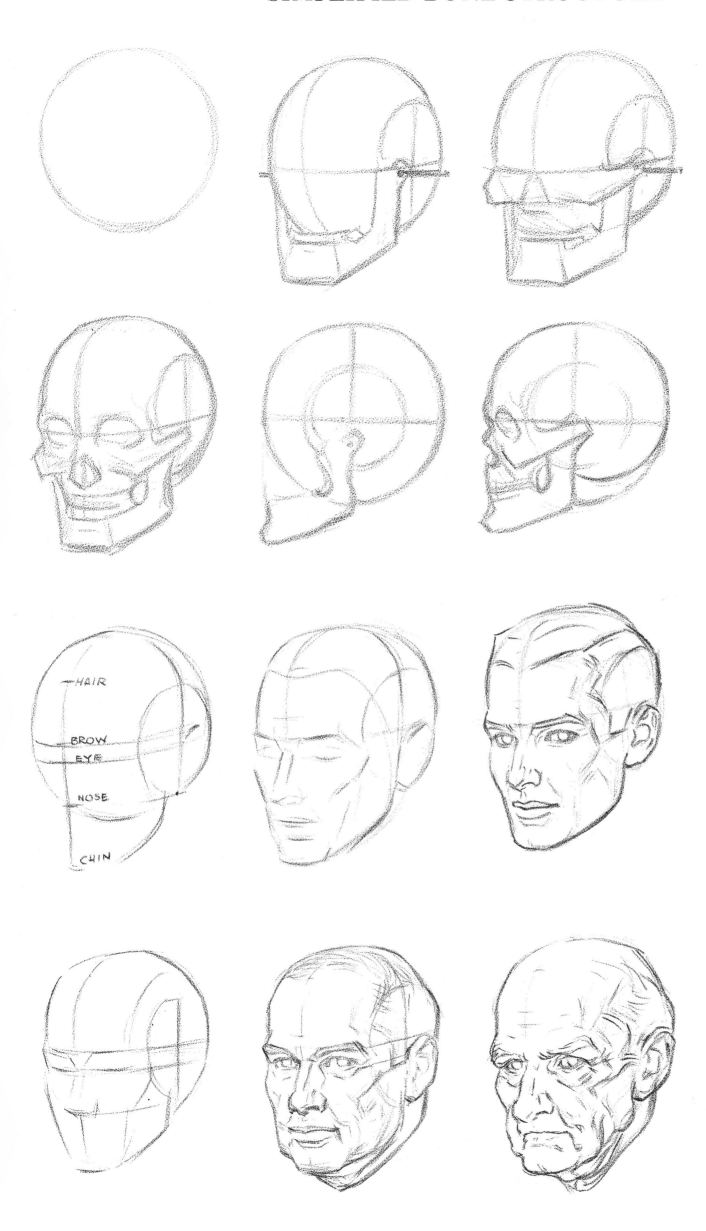

At this point it will help a great deal in constructing the head to have a fairly clear idea of the bone structure. Though we do not see the bones in detail, we must think of them as the framework of the head. All the division points of the head are related to the bones, not to the flesh. The reason we chose the ball and plane as an approach now becomes apparent, for our approach is the skull itself, simplified and made understandable.

You can easily learn to age a face by adding the forms of the emaciating muscles and the creases that fall between them. The cheekbones, the corners of the jaw, and the bone of the chin become more evident in the aging process. The cartilages of the nose and ears seem to get larger as we get older. The chief change takes place in the cheeks and around the eyes and mouth. The flesh sags at the sides of the chin and along the sides of the jaw. Pouches form under the eyes, and deeper lines at the corners of the eyes. The lips tend to get thinner and move inward, so that more of a straight line between the lips is produced. The lines develop from the corners of the mouth down around the sides of the chin. The flesh above the eyelids droops and the brows seem to drop inward toward the bridge of the nose. A few deeper lines develop across the forehead and between the brows. These can be subordinated, to avoid overemphasizing them. The hair, of course, thins out in varying degrees, so that the hairline moves up and back and there is considerable thinning of the hair at the top of the head. However, we draw the head from the same basic construction.

THE CROSS AND THE MIDDLE LINE DETERMINE THE POSE.

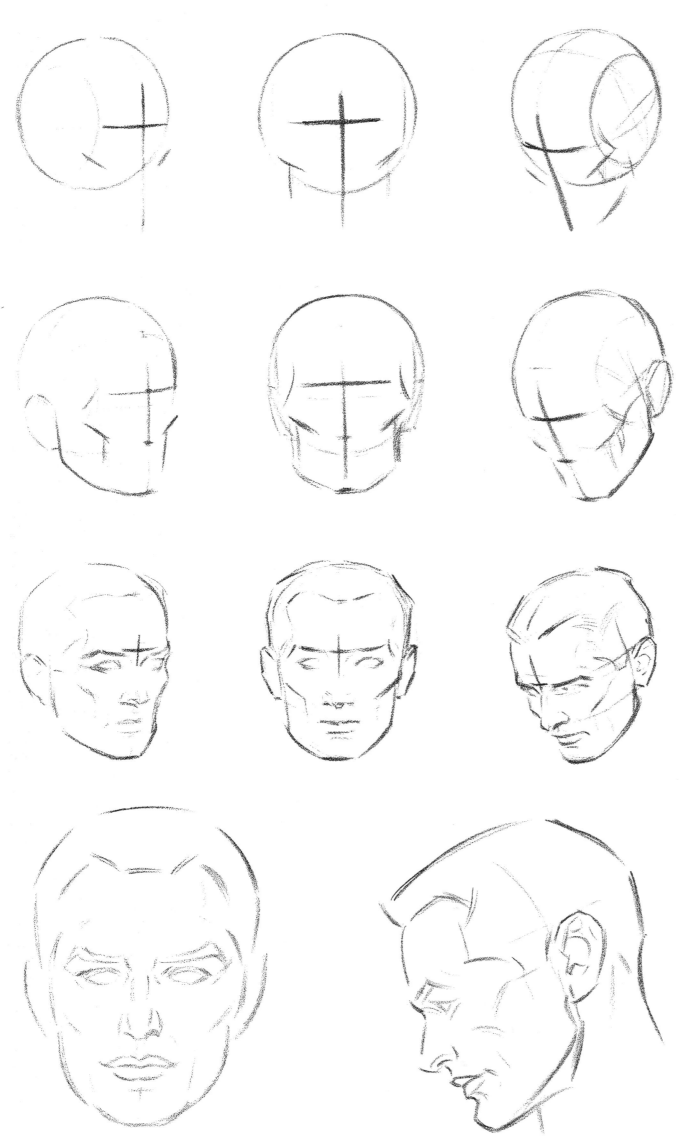

It is most important to begin at once to practice setting up the ball and facial plane. Do not worry too much now about the features. This is simply construction, which you will probably use for the rest of your life. Establish the cross. Try to think of the construction all around the head, so that the jaws attach halfway around on each side. Remember that the eyes and cheekbones are below the brow line. The ears are about parallel with the lines of the brows and that of the nose. The cross almost suggests the face below. With this approach we can start drawing the whole head in any pose. This simple plan is the only approach that is at the same time creative and accurate. Any other accurate approach requires mechanical means, such as the projector, tracing the pantograph, or using a squared-off enlargement. The big question is really whether you wish to develop the ability to draw a head, or whether you are content to use mechanical means of projecting it. My feeling is that, if the latter were the case, you would not have been interested in this book. When your bread and butter depends upon creating an absolute likeness, and you do not wish to gamble, make the best head you can by any means possible. However, if your work is to give you joy and the thrill of accomplishment, I urge you to aim at the advancement of your own ability.

THE BASIC SHAPE IS A FLATTENED BALL

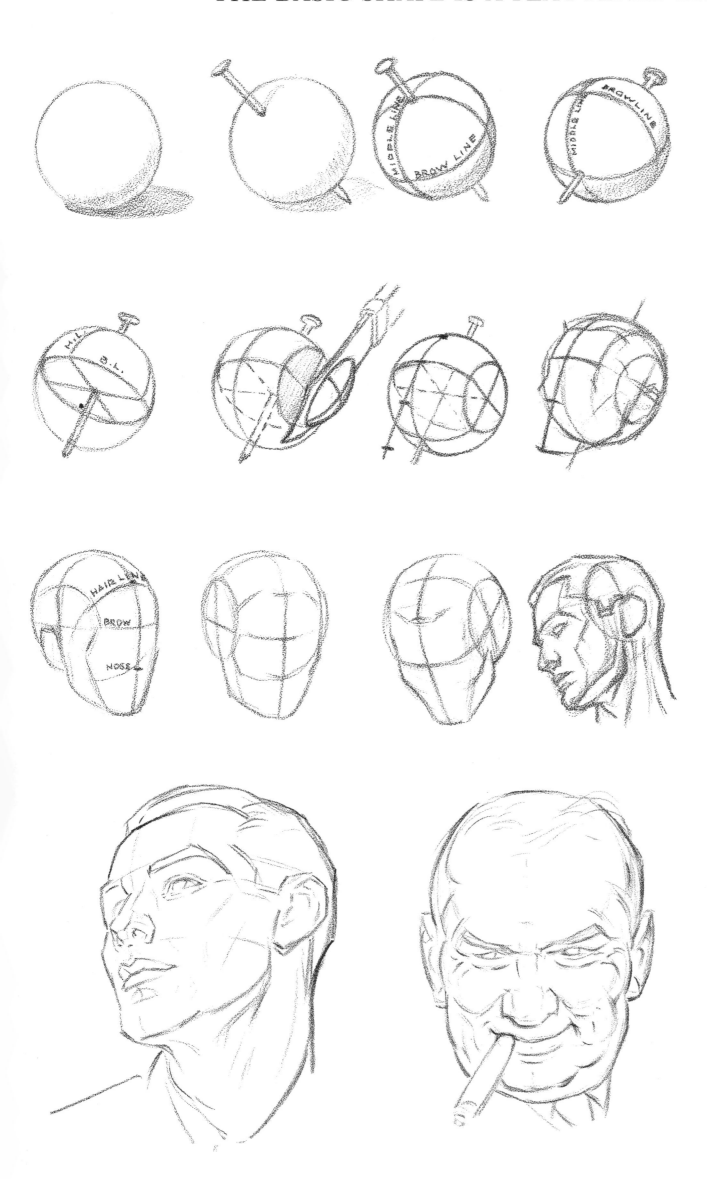

The cranium is more like a ball than anything else. To represent the ball as a solid sphere, we must establish an axis, like the nail through the ball at the top. Through the centers established by the axis, we can divide the ball into quarters and again at the equator. Now if we were to slice off a fairly thin slice on each side, we will have produced a basic shape that very closely matches the cranium. The "equator" becomes the brow line. One of the lines through the axis becomes the middle line of the face. About halfway up from the brow line to the axis, we establish the hairline, or the top of the face. We drop the middle line straight down off the ball. On this we mark off two points about equal to the space of the forehead, or from brow line to hairline. This gives us the length of the nose, and below that the bottom of the chin. We can now draw the plane of the face by drawing in the jaw line, which connects about halfway around the ball on each side. The ears attach along the halfway line (up and down) at a distance about equal to the space of from the brows to the bottom of the nose. The ball can be tipped in any direction.

Any direct and efficient approach must presuppose the skull and its parts and its points of division. It is just as reasonable to start drawing a wheel with a square as it is to start drawing a head with a cube. By cutting off corners and further trimming the square you could eventually come out with a fairly good wheel. You could also chip away the cube until you had a head. But at best it's a long way around. Why not start with the circle or ball? If you can't draw a ball, use a coin or a compass. The sculptor starts with a form of the general shape of the face attached to the ball of the cranium. He could not do otherwise.

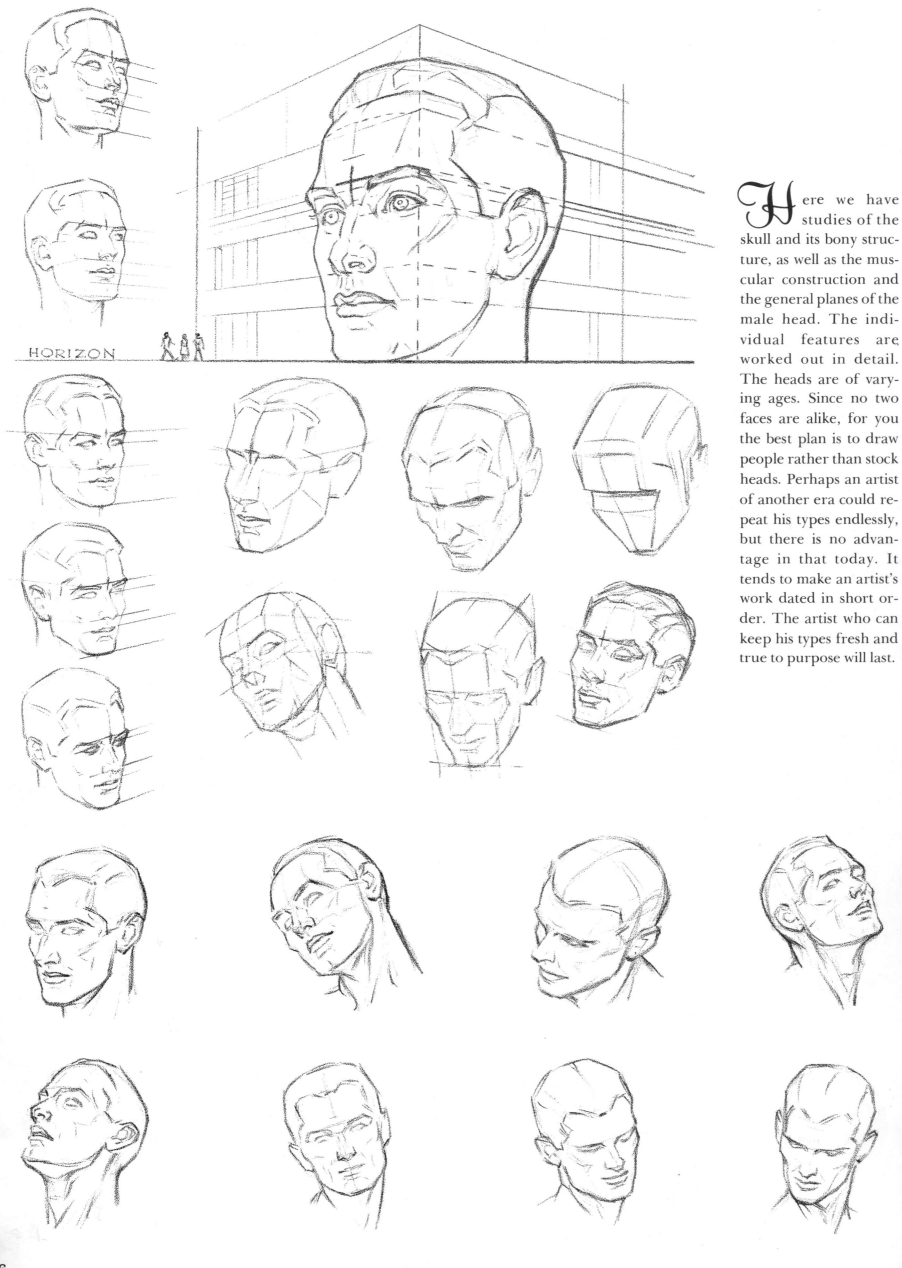

HORIZON

Here we have studies of the skull and its bony structure, as well as the muscular construction and the general planes of the male head. The individual features are worked out in detail. The heads are of varying ages. Since no two faces are alike, for you the best plan is to draw people rather than stock heads. Perhaps an artist of another era could repeat his types endlessly, but there is no advantage in that today. It tends to make an artist's work dated in short order. The artist who can keep his types fresh and true to purpose will last.

ACTION OF THE HEAD ON THE NECK

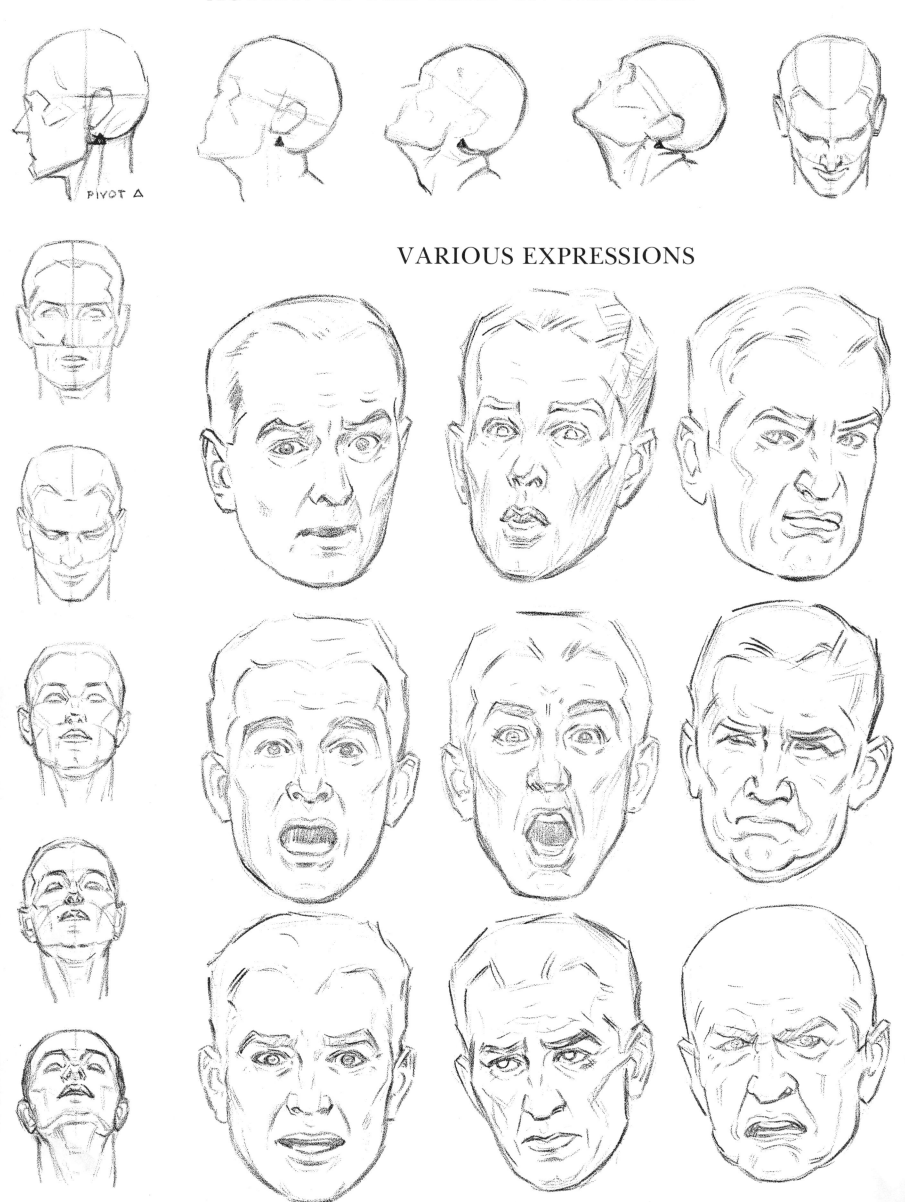

PIVOT △

VARIOUS EXPRESSIONS

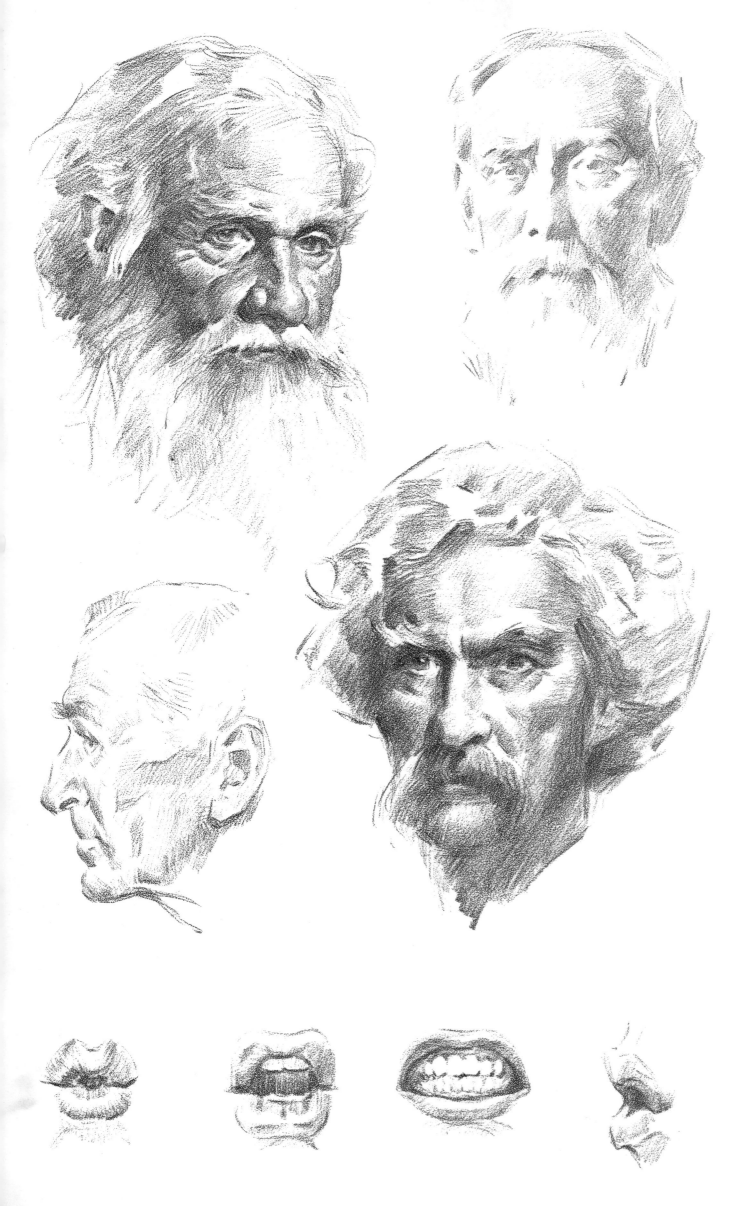

The head, perhaps, has more to do with selling a drawing than anything else. Though the figure drawing you submit may be a splendid one, your client will not look beyond a homely or badly drawn face. I have often worried and labored over this fact in my own experience. Once something happened that has helped me ever since. I discovered construction. I discovered that a beautiful face is not necessarily a type. It is not hair, color, eyes, nose, or mouth. Any set of features in a skull that is normal can be made into a face that is interesting and arresting, if not actually beautiful. When the face on your drawing is ugly and seems to leer at you, forget the features and look to the construction and placement of them. No face can be out of construction and look right or beautiful. There must be a positive balance of the two sides of the face. The spacing between the eyes must be right in relation to the skull. The perspective or viewpoint of the face must be consistent with the skull also. The placement of the ear must be accurate, or a rather imbecilic look results. The hairline is extremely important because it not only frames the head but helps to tip the face at its proper angle.

The placement of the mouth at its proper distance between nose and chin can mean the difference between allure and a disgruntled pout. To summarize, draw the skull correctly from your viewpoint and then place the features properly within it.

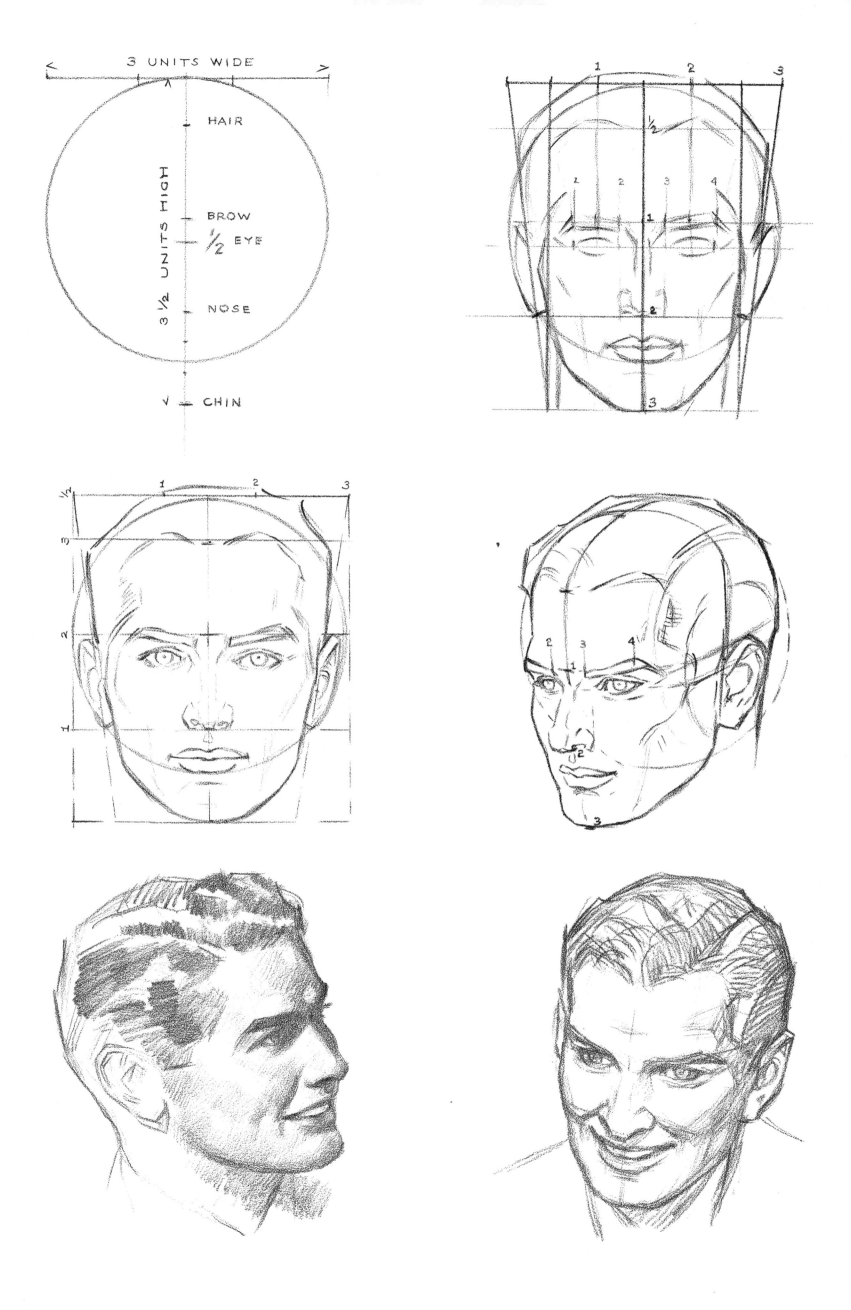

3 UNITS WIDE

3 ½ UNITS HIGH

HAIR

BROW
½ EYE

NOSE

CHIN

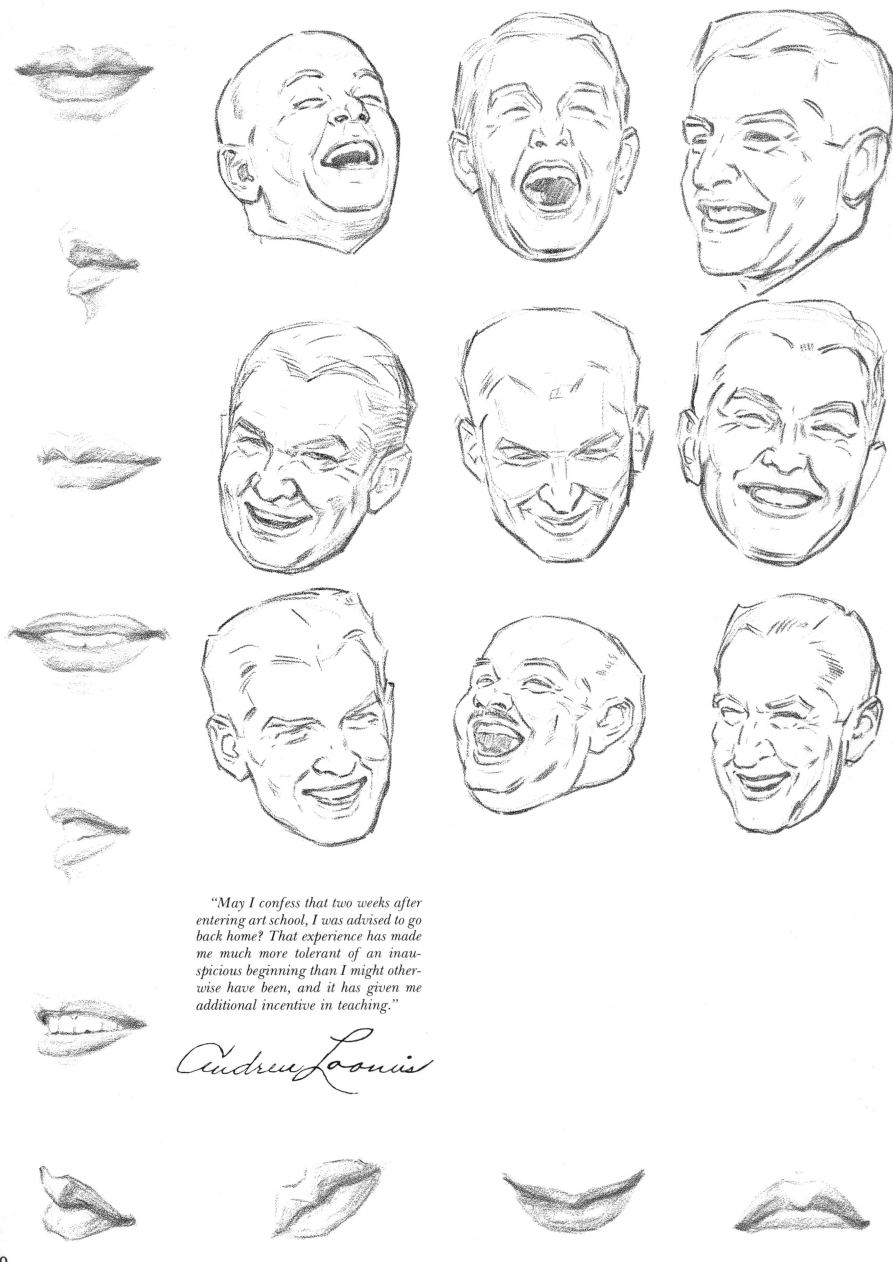

"May I confess that two weeks after entering art school, I was advised to go back home? That experience has made me much more tolerant of an inauspicious beginning than I might otherwise have been, and it has given me additional incentive in teaching."

Andrew Loomis

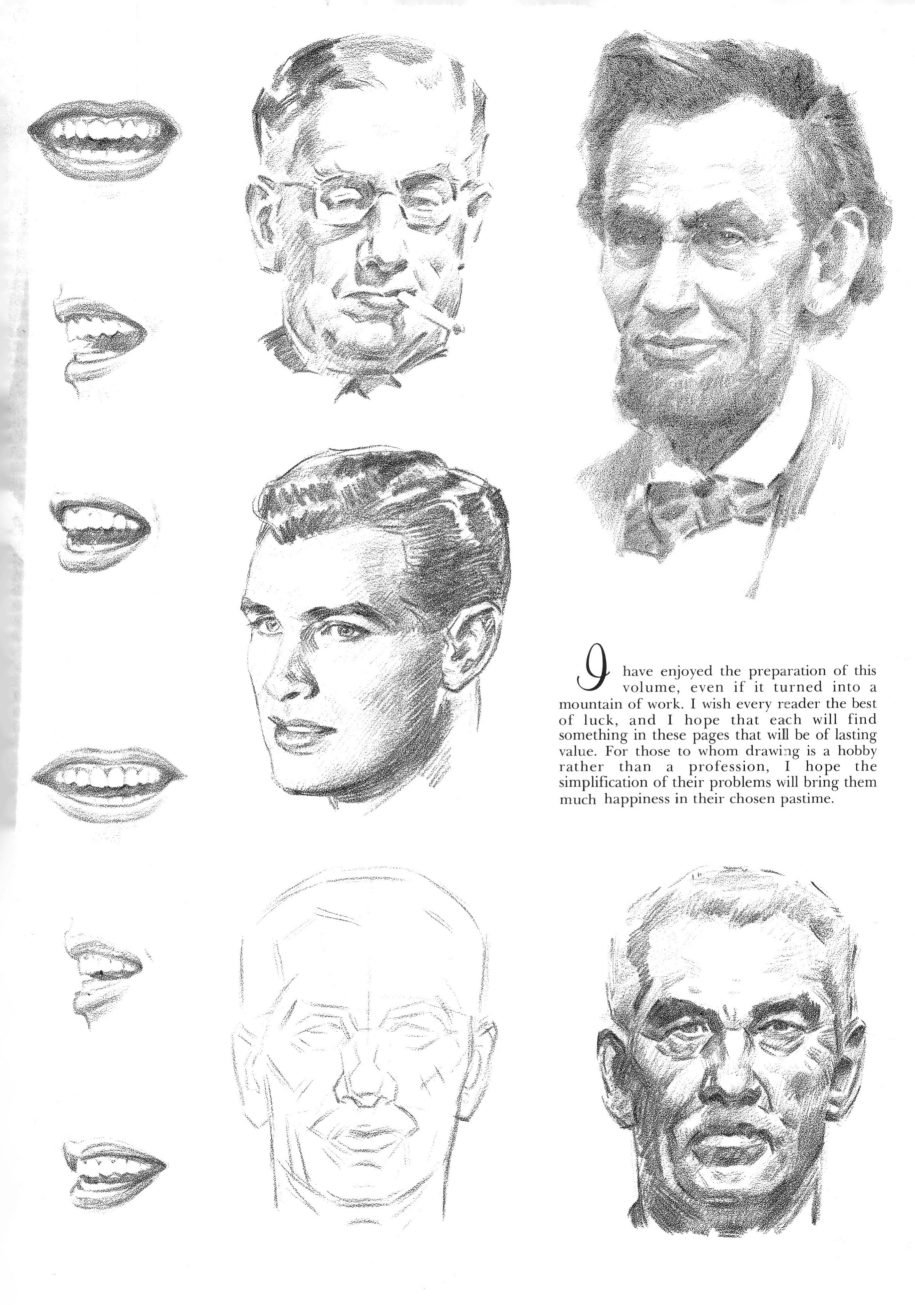

I have enjoyed the preparation of this volume, even if it turned into a mountain of work. I wish every reader the best of luck, and I hope that each will find something in these pages that will be of lasting value. For those to whom drawing is a hobby rather than a profession, I hope the simplification of their problems will bring them much happiness in their chosen pastime.

More Ways to Learn

Collector's Series

CS01 CS03 CS02

Artist's Library

AL26 AL04 AL02

The **Artist's Library** series offers both beginning and advanced artists many opportunities to expand their creativity, conquer technical obstacles, and explore new media. You'll find in-depth, thorough information on each subject or art technique featured in the book. Each book is written and illustrated by a well-known artist who is qualified to help take eager learners to a new level of expertise.

Paperback, 64 pages, 6-1/2" x 9-1/2"

Collector's Series books are excellent additions to any library, offering a comprehensive selection of projects drawn from the most popular titles in our How to Draw and Paint series. These books take the fundamentals of a particular medium, then further explore the subjects, styles, and techniques of featured artists.

CS01, CS02, CS04: Paperback, 144 pages, 9" x 12"

CS03: Paperback, 224 pages, 10-1/4" x 9"

How to Draw and Paint

HT265 HT266 HT268

HT264

The **How to Draw and Paint** series includes these five stunning new titles to enhance an extensive collection of books on every subject and medium to meet any artist's needs. Specially written to encourage and motivate, these new books offer essential information in an easy-to-follow format. Lavishly illustrated with beautiful drawings and gorgeous art, this series both instructs and inspires.

Paperback, 32 pages, 10-1/4" x 13-3/4"

Walter Foster products are available at art and craft stores everywhere. Write or call for a FREE catalog that includes all of Walter Foster's titles. Or visit our website at www.walterfoster.com

Walter Foster™

Walter Foster Publishing, Inc. • 23062 La Cadena Drive • Laguna Hills, CA 92653 • (800) 426-00